Royal Academy Illustrated 2001

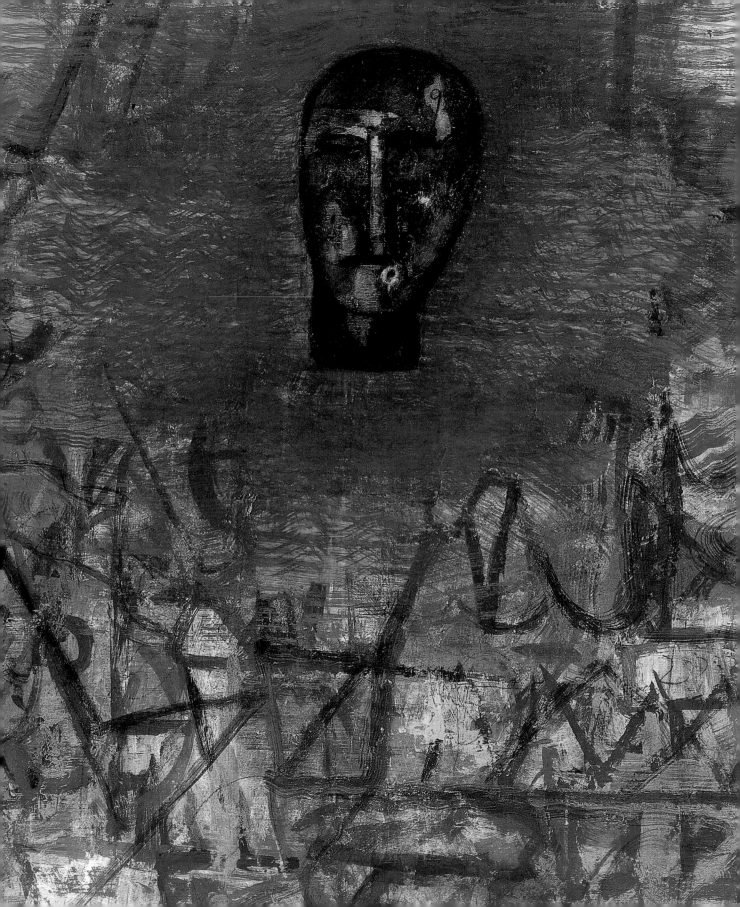

'Now they'll paint the town red'
Puck, 1906

Royal Academy Illustrated 2001

A selection from the
233rd Summer Exhibition

Edited by Peter Blake RA

Royal
Academy
of Arts

Sponsored by
AT KEARNEY
Management Consultants

Acknowledgements

The organisers of the Royal Academy Summer Exhibition 2001 would like to thank the following institutions and individuals for their kind assistance: Angela Flowers Gallery; Anthony d'Offay, Susanna Greeves, Lorcan O'Neil and Joanna Thornberry of Anthony d'Offay Gallery; Charles Asprey of asprey jacques; Alan Cristea; Mollie Dent-Brocklehurst, Larry Gagosian and Stefan Ratibor of the Gagosian Gallery; Bernard Jacobson; Martin Summers of the Lefevre Gallery; Lisa Rosendahl and Jill Silverman van Coenegrachts of the Lisson Gallery; Arianne Banks and David Case of Marlborough Fine Art Ltd; Sadie Coles and Pauline Daly of Sadie Coles HQ; Alain Sayag; Karsten Schubert; Hugh Allen and Sian Thomas of Science; Tate; Timothy Taylor Gallery; the Usher Gallery, Lincoln; Kelly Taylor of Victoria Miro Gallery; Sir Thomas Lighton, Felix Mottram and Leslie Waddington of Waddington Galleries; Irene Bradbury and Jay Jopling of White Cube, London; Colin Wiggins; and the Wyeth Study Centre, Maine.

Contents

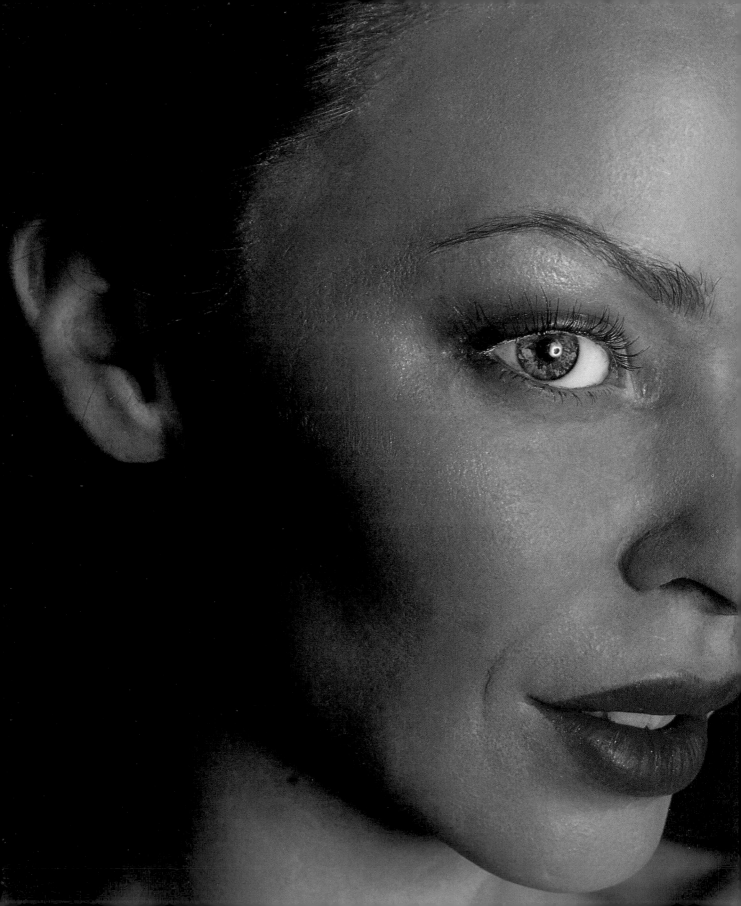

Sponsor's Preface

One of the first and easiest decisions I took as the new Managing Director at A.T. Kearney in London was to extend our role as sponsor of the Summer Exhibition at the Royal Academy of Arts, through to 2004. The Summer Exhibition is part of the fabric of British life and we have found our relationship with it to be more rewarding each year. In particular, the Royal Academy's nurturing of creativity is extremely attractive to us because we seek to promote this vital ingredient in every aspect of our work.

A.T. Kearney is one of the leading management consulting firms in the world. We assist organisations to develop practical plans for growth in new and existing markets and business sectors. We help businesses develop world-class operations that serve their customers in a superior and competitively differentiated manner. Our people combine industry experience with creative insight to deliver rapid, sustainable results as part of a team with our clients.

An artist will deconstruct the familiar, rearrange all the elements and create from this foundation a new awareness of the original. This process is mirrored in all our client work as management consultants, and is exemplified by our Portraits of Business project – an exciting and unique initiative, launched last year, to demonstrate the tie between the arts and business.

Once again, we have enjoyed our relationship with the Royal Academy of Arts sponsoring this year's Summer Exhibition. We look forward to strengthening the relationship between arts and business through our continued sponsorship over the next three years.

We hope that visitors will be inspired by this year's display of variety and innovation.

Carl Hanson
UK Managing Director
A.T. Kearney Limited

Introduction

Every year the Summer Exhibition has a different profile, moulded by the Academician in charge. This year, Peter Blake has combined the offices of Senior Hanger and Editor of the *Illustrated*. His involvement, from selection and hanging to designing the poster and banner, has been comprehensive.

In a controversial move, Blake asked Academicians to submit four works instead of the usual six, so that more room would be available for other work: 'It's four exhibitions: the Honorary Membership in Galleries I and II; invited artists in the Large Weston Room; Members in Galleries III and IV and in the Wohl Central Hall, with Fred Cuming, this year's featured artist, in the Small Weston Room; and non-Members in Galleries V, VI and VII. There'll also be a mixed sculpture exhibition in Gallery VIII, hung by Richard Deacon, and mixed works on paper in the Lecture Room. Gallery IX is for the architects.'

Blake's poster echoes this division. Its source – a 1906 penny dreadful called *Puck* – displays the gentle humour typical of Blake: 'It's like a comic book. The banner at the top just has the word "Summer" in flowers and then some little comic figures and a dog – an early version of Bonzo – who's saying "Now they'll paint the town red!"' Pictures on the poster by an Honorary RA, a non-Member, an invited artist and a Member all feature flowers: 'Flowers were the other motif in my mind,' says Blake. 'It's not exactly a contrast to *Apocalypse*, but it's a joyful summer flower mood.'

Reactions to limiting the Members' send-in were not entirely positive. Did this worry Blake? 'I don't mind being unpopular, I just want to make it a wonderful exhibition. I thought there'd be a boycott, but there doesn't seem to have been.' A notable feature this year is the quality and quantity of work by Honorary Academicians – international painters and sculptors recognised by the RA as artists of special stature. Work by invited artists – Blake's friends and contemporaries, or simply artists he admires – gives the show a very particular flavour.

Blake continues: 'Outside in the Courtyard will be a 25-foot-high anvil on its side with a hare dancing on it by Barry Flanagan; a red, cut-out steel figure by Allen Jones; and a Jeep full of figurative collection-boxes by David Mach.' In effect, it will look rather like a Peter Blake installation.

Opposite: The issue of Puck that provided Peter Blake with the source material for this year's Summer Exhibition poster. Previous page: Rankin's 'Wax Kylie', C-type photograph

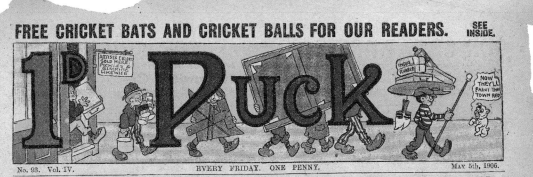

1D Puck

No. 93. Vol. IV. EVERY FRIDAY. ONE PENNY. MAY 5th, 1906.

JOHNNY JONES AT THE ACADEMY. ANOTHER NOBLE WORK OF ART REJECTED.

1, It is rumoured that Johnny Jones and his chums recently took up art as a profession. Interviewed by a PUCK representative, Professor Willie Wagstaff said : "Yes, it's quite true. With proper grown-up paints and a north light anybody can be an artist, and write R.A.T.S. after his name." So now, dear readers, you are privileged to see our young friends at work upon their great masterpiece, "Why Julius Cæsar Didn't Come Home to Tea."

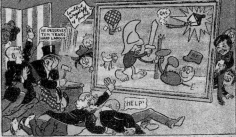

2, A PUCK man called at the Royal Academy yesterday to find out why the magnificent work had been rejected ; but the committee merely stated that hanging was too good for it, and would not commit themselves further. Many of the members are still suffering from shock and severe injuries to the eyesight. "Perhaps we ought not to have let 'em see it, all at once," chirped Johnny to his brother brushes ; "some of the gentlemen don't look very strong."

3, Then a stout person in a pretty uniform (the president, no doubt) came up and pushed the Caseyites off the premises with his academic boot, whilst Johnny, who hates to give unnecessary trouble, took a special non-stopping route on his own responsibility, and so saved his dignity, and his trousers.

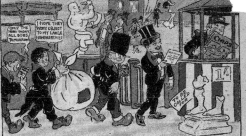

4, The next day our hero obtained some tickets for the private view, and the Casey boys arrived in full Court dress, which for style and cut would have made Johnny Burns turn black and blue with envy. The giddy old check-taker was so busy reading Chips that he failed to notice the mysterious bundle they had brought with them.

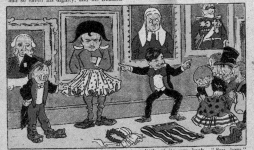

5, And this is where neglected genius gets a little of its own back. "Say, boys," chirped Johnny, "how does old Nap go as Queen of the May, mother ?" "All right !" yelled Willie Wagstaff. "But you jest wait till we've dressed Mr. Justice Funniman up for a coon song and dance ! Wot ?"

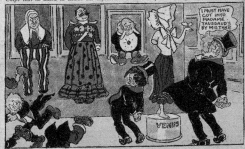

6, No wonder grandpa thought that he'd taken the wrong turning, and got himself fairly twisted with surprisement. "Come along, boys !" piped Willie Wagstaff ; "let's get right off the page—we've done quite enough good for one week, I don't think."

9

Gallery I

This year's Summer Exhibition is distinguished by an altogether clearer hang than usual. Categories of work have been kept distinct and separate, bringing a recognisable identity to each gallery. Under Peter Blake's guidance, Galleries I and II have been given over to the work of the Honorary RAs, artists of international celebrity such as Georg Baselitz and Robert Rauschenberg. Good examples of their work have been rigorously sought out to raise the calibre of these rooms. In cases where an artist is both a painter and sculptor, for example Chillida, Tàpies or Paladino, pieces in each medium have been borrowed and hung together. There's a watercolour by Andrew Wyeth, 'the only one in the country', Blake thinks. Next to it hang two paintings from one series by Cy Twombly. 'What I found fascinating is that in the scribbled writing you can just work out "Think of Chet", which I like to think is Chet Baker, who's my great hero,' comments Blake. Two works by Jasper Johns, a drawing and a print, follow, and then comes a wonderfully textured work on paper, like a black sun, by Richard Serra. Across the room is a mysterious new Rauschenberg, a vegetable-dye transfer on polylaminate. A large and unframed recent canvas by the nonagenarian Chilean painter Matta is stapled to the wall. As Blake says, it looks like an octopus facing a crystalline box explosion.

Antoni Tàpies Hon RA
Baignoire
Enamel and terracotta
H 62 cm

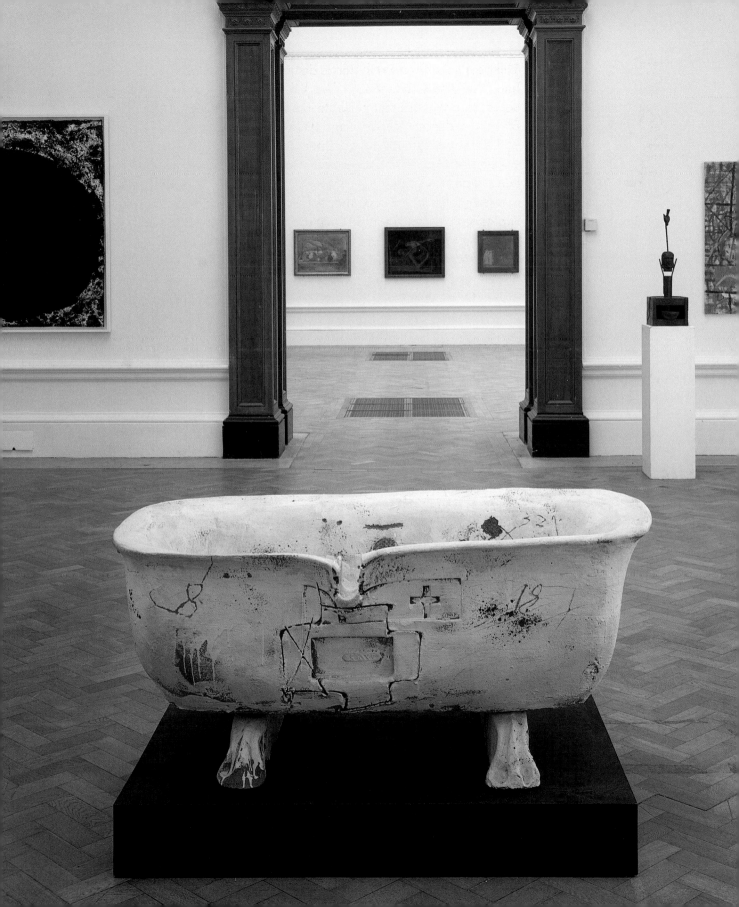

Antoni Tàpies Hon RA
Pensament (Thought)
Oil
90 × 120 cm

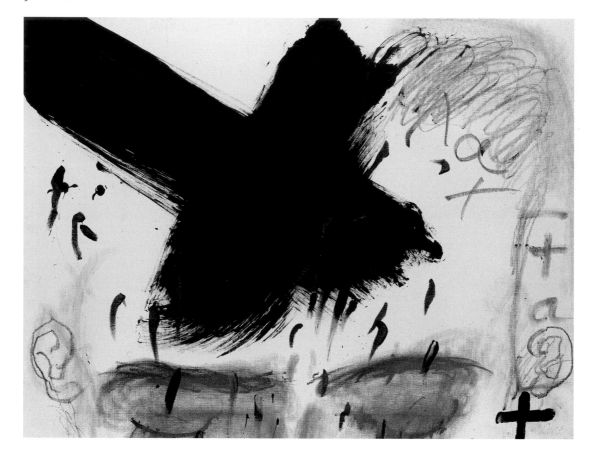

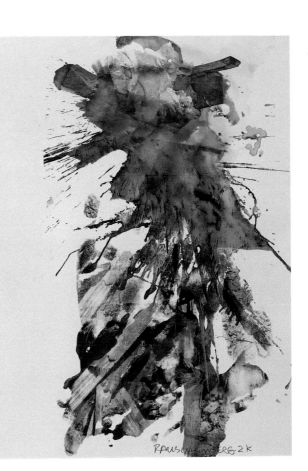

Robert Rauschenberg Hon RA
EE (Apogamy Pods)
Vegetable-dye transfer on polylaminate
217 × 216 cm

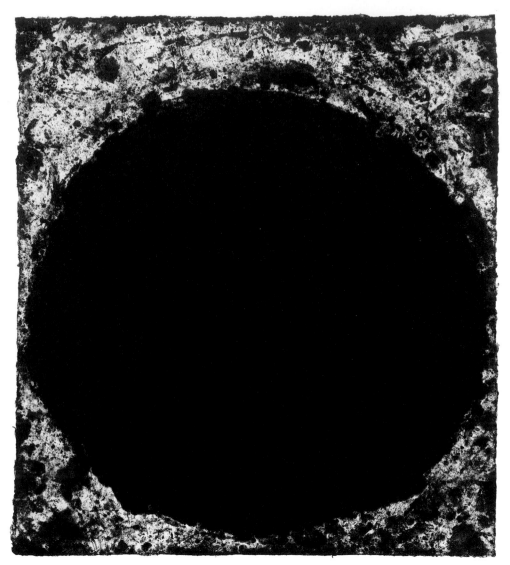

Richard Serra Hon RA
Huddie Leadbelly
Paintstick on paper
156 × 139 cm

Cy Twombly Hon RA
Untitled (diptych)
Acrylic and graphite
277 × 154 cm

Eduardo Chillida Hon RA
Sculpture
Terracotta
H 22 cm

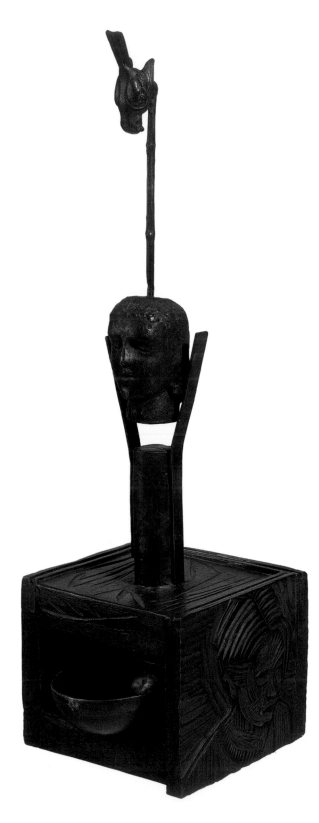

Mimmo Paladino Hon RA
Scatola con uccello su testina
Bronze
H 80 cm

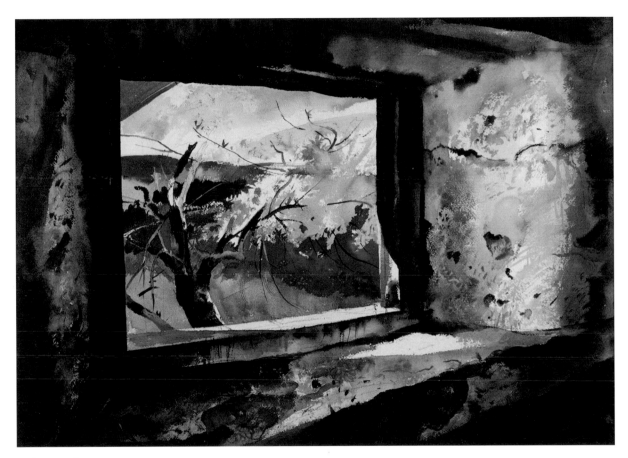

Andrew Wyeth Hon RA
From an Attic Window
Watercolour
53 × 74 cm

Matta Hon RA
The Ego and His Own Own, 98/8
Oil
310 × 500 cm

Gallery II

The spare elegance of the hang in Gallery I continues in Gallery II. The main feature of the room is a memorial group of five pictures by Balthus. Their subjects, not the obviously controversial depictions of young girls, show a different side of the artist. Among the group there's an early self-portrait, a still-life of oranges and apples, and a landscape watercolour. The only other paintings here are a large canvas of a sideways dog floating over mountains by Baselitz, and a huge Kiefer. This mixed media painting, on lead mounted on canvas, is horizontally bisected by a whitened, skeletal branch and dedicated to Robert Fludd, the seventeenth-century English physician and mystic. Entitled *The Secret Life of Plants*, it is littered with numbers like astral co-ordinates, and begs to be decoded. This room also contains two-dimensional work (mostly photographic) by some of the Honorary architects: Frank Gehry, Arata Isozaki and I. M. Pei. Four small Frank Stella iron sculptures hold the centre of the floor.

Balthus Hon RA
The First Communicants *(detail)*
Oil
55 × 53 cm

Frank Stella Hon RA
Contz-Les Bains-Spa Sculptures
Cast and fabricated stainless steel
H 45 cm

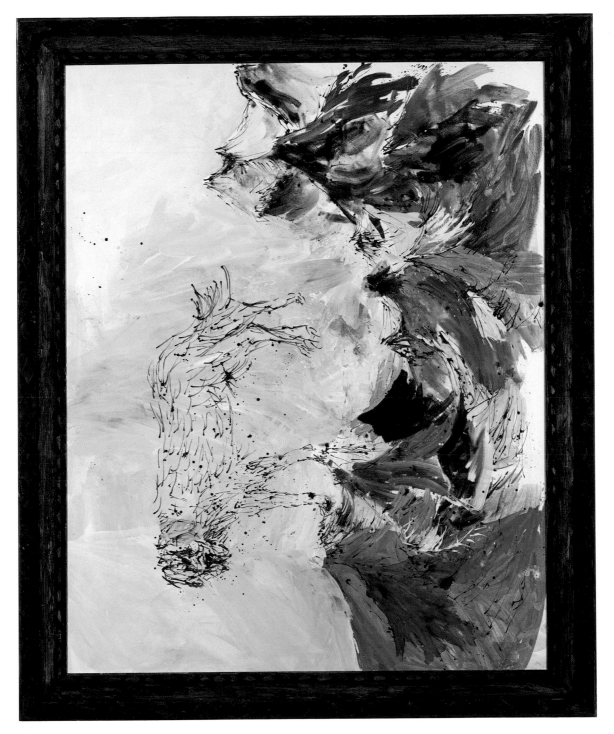

Georg Baselitz Hon RA
Der Glaube versetzt Berge (Faith Moves Mountains)
Oil
270 × 210 cm

Anselm Kiefer Hon RA
For Robert Fludd:
The Secret Life of Plants
Mixed media
197 × 333 cm

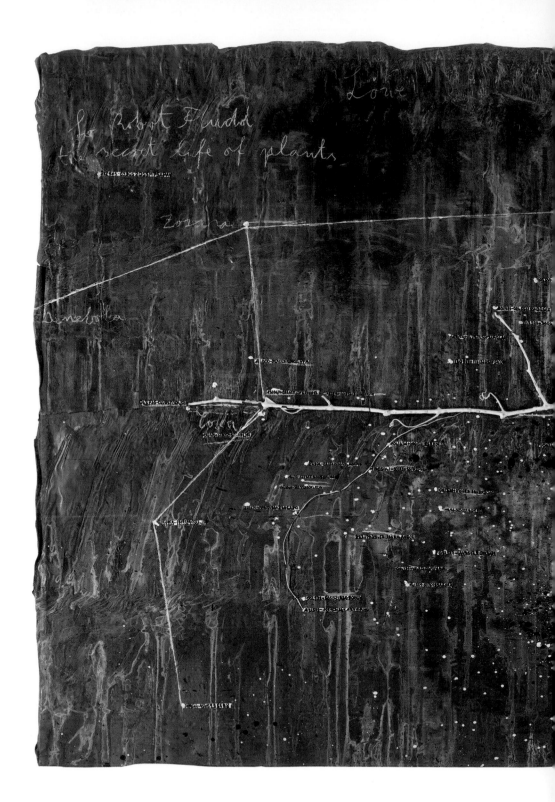

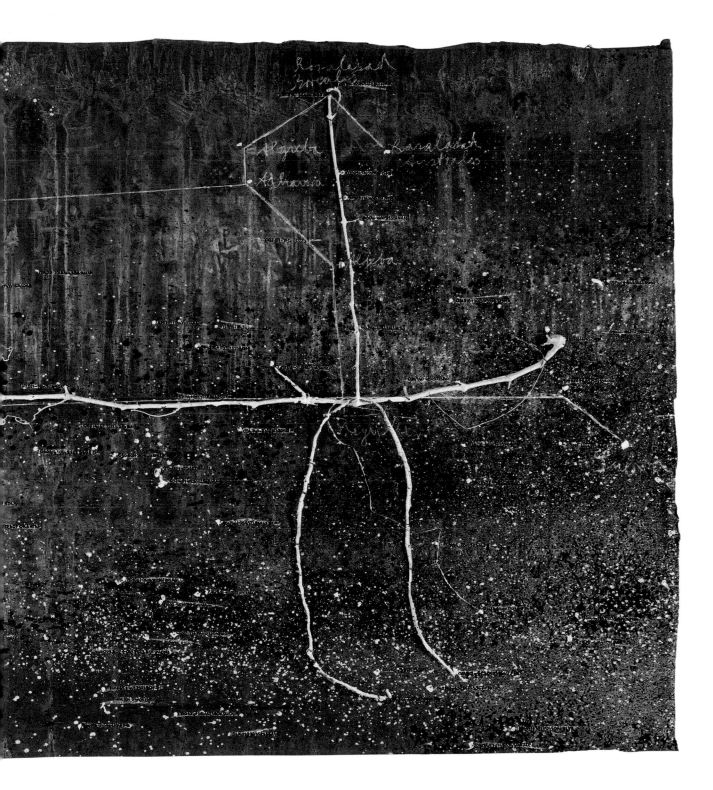

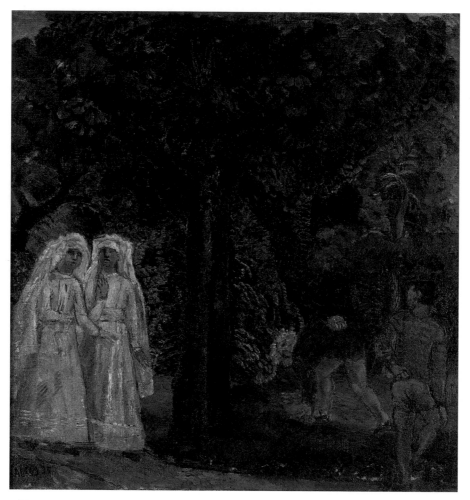

Balthus Hon RA
The First Communicants
Oil
55 × 53 cm

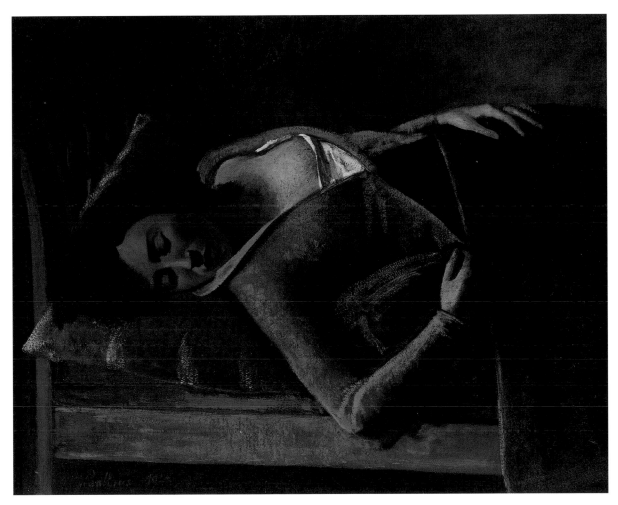

Balthus Hon RA
Sleeping Girl
Oil
82 × 100 cm

This gallery showcases artists invited to exhibit by Peter Blake. They include old friends, such as Blake's fellow Pop artist Colin Self, four of whose prints hang as a block, Bridget Riley, Bernard Cohen, Richard Smith and the Brotherhood of Ruralist painters, such as Graham and Ann Arnold and Graham and Annie Ovenden. The Ruralists, of which Blake was a founding member, showed as a group for the first time in the Summer Exhibition in 1976, the previous time Blake, as Senior Hanger, made a foray into showing a room of invited artists. Of the younger set, the Wilson Twins have photographed a locker room in the Russian Space Programme; Damien Hirst contributes a large spot painting; and Tracey Emin exhibits an embroidered chair. There are two photographs by Rankin of Kylie Minogue – as Blake comments 'they're like the old-time Academy "problem pictures". The problem is that the photo on the left is definitely of a waxwork, but is the one on the right also a waxwork, or a portrait of her from life?'

Another Pop artist, Clive Barker, is represented by a real refrigerator filled with chromium food. 'It's brilliant, a beautiful piece,' says Blake. 'There's a real American hot-dog jar with the label on, but the hot dogs are chrome.' Objects feature here as much as the paintings. 'A very interesting theme of new figurative sculpture has emerged. There's a Marc Quinn disability piece, Don Brown's half-life-size figure, and Sarah Lucas has made a garden gnome covered in cigarettes. There's also Nicholas Dimbleby's portrait of Steve Redgrave. When I invited artists in 1976 Dimbleby sent in a fountain, which I made the centrepiece then, so this is a kind of reference to that.' Ron Mueck was persuaded to lend a group of studies and maquettes. Pop stars who paint make an appearance, too: 'There are three musicians I feel are serious painters – Paul McCartney, Ronnie Wood and Holly Johnson. It's not a publicity stunt: they're here as painters. We haven't flagged them up.' There's also a 1960s painting by the late Ian Dury, whom Blake taught at art school.

Richard Patterson
Untitled (Kiss), detail
Oil
208 × 244 cm

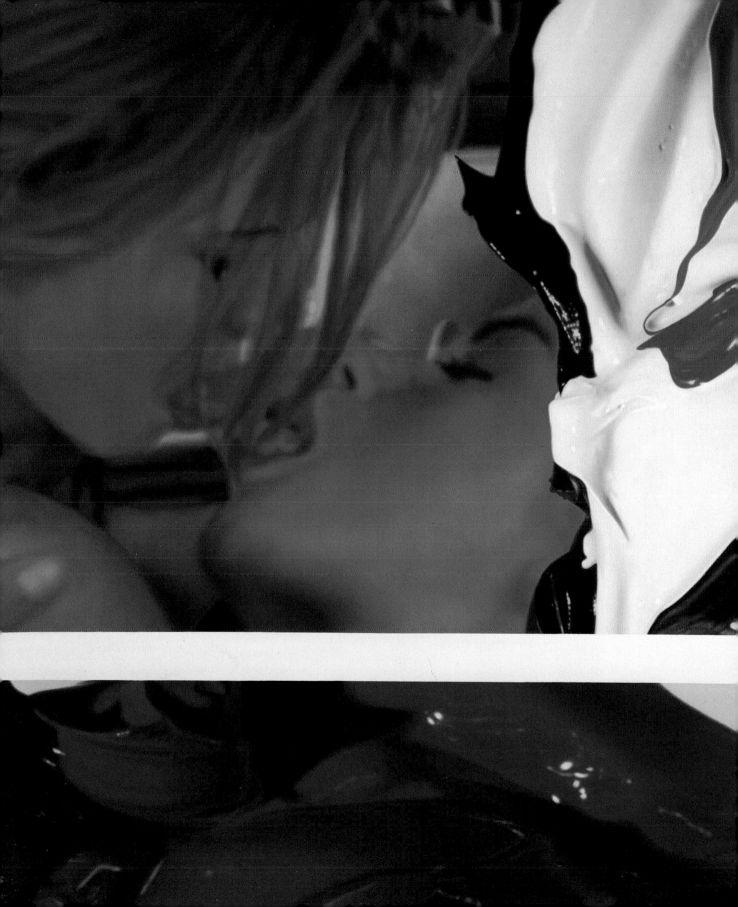

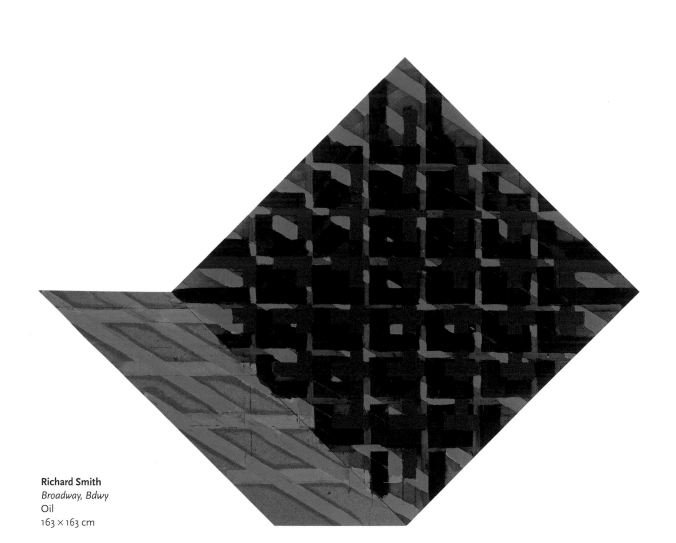

Richard Smith
Broadway, Bdwy
Oil
163 × 163 cm

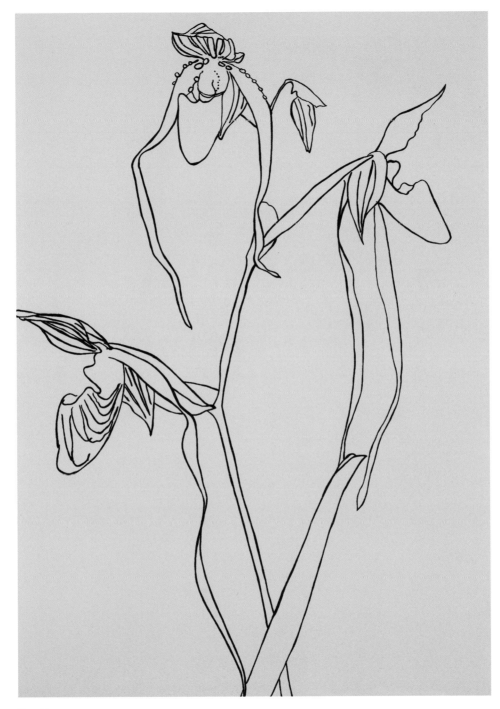

Gary Hume
Orchid I
Gloss paint on aluminium
95 × 66 cm

Bernard Cohen
Zany in a Detail 2000
Oil
183 × 244 cm

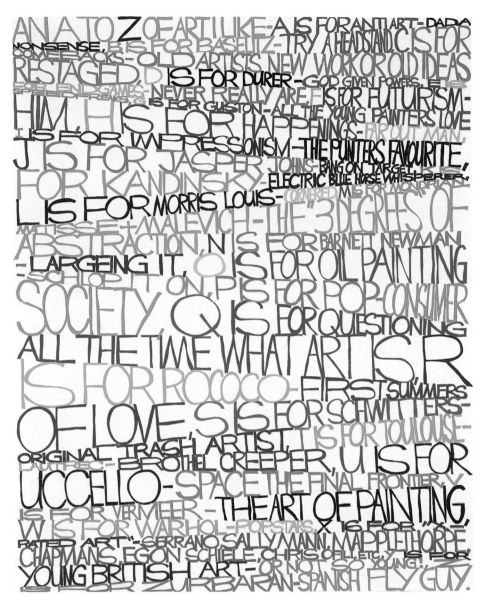

Peter Davies
From Anti-art to Zurbaran
Acrylic
228 × 183 cm

Tracey Emin
There's a Lot of Money in Chairs
Mixed media
H 69 cm

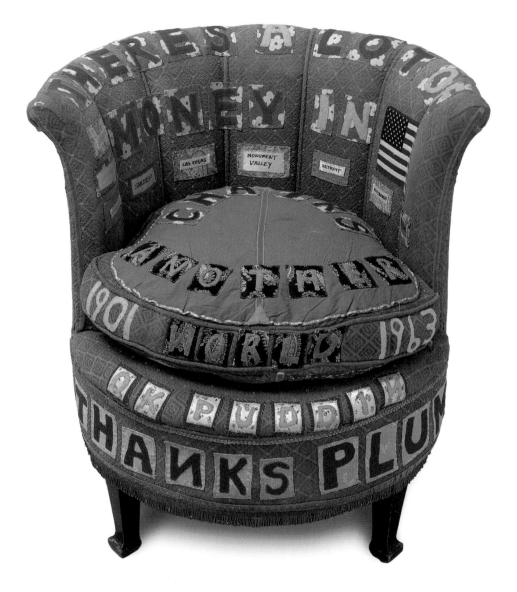

Sarah Lucas
Fag Work
Fags
H 86 cm

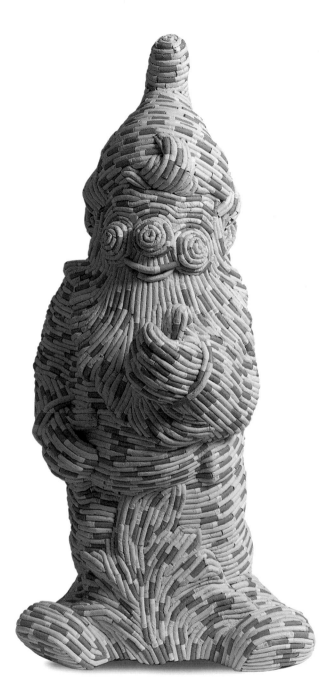

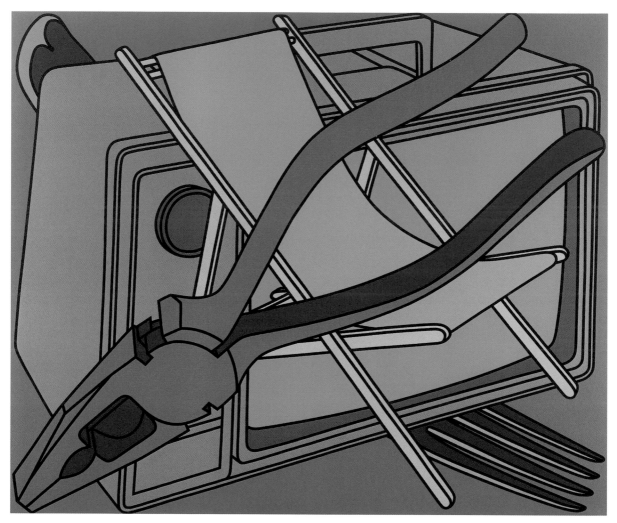

Michael Craig-Martin
Untitled
Acrylic
180 × 240 cm

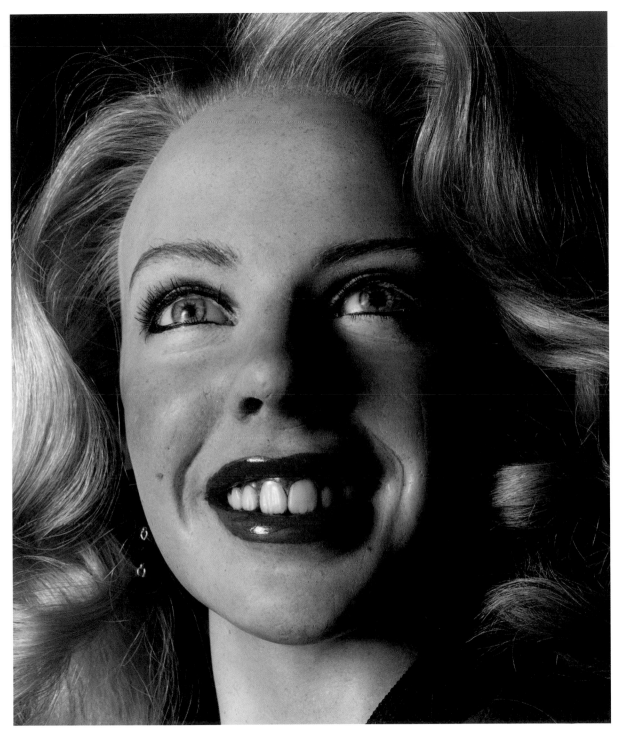

Rankin
Wax Kylie
C-type photograph
152 × 122 cm

Colin Self
A Quartet Panel from the Odyssey (first volume of 34 works)
Etching
106 × 74 cm

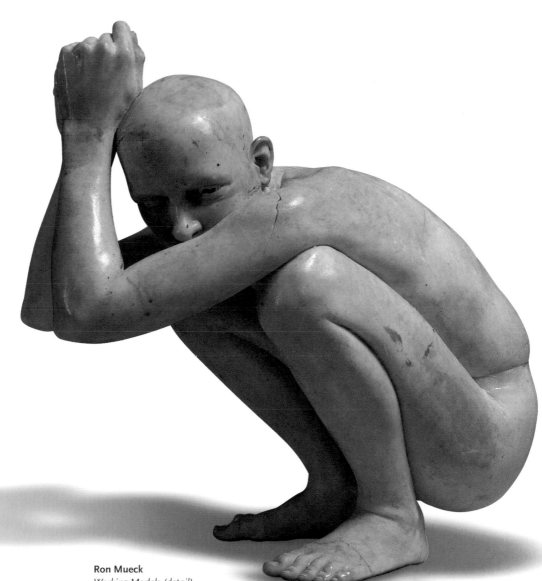

Ron Mueck
Working Models (detail)
Mixed media
H 46 cm

Sam Taylor-Wood
Self Portrait as a Tree
C-type print
76 × 91 cm

Ann Barbara Arnold
Tending the Tire
Oil
122 × 92 cm

David Inshaw
November 5, Gunpowder, Treason and Plot
Oil
127 × 152 cm

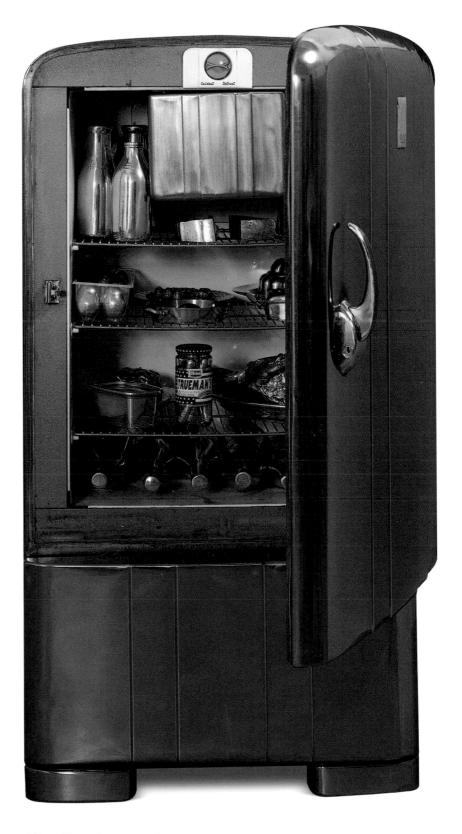

Clive Barber
Fridge
Mixed media
H 133 cm

Small Weston Room

Frederick Cuming is this year's featured artist, and is thus accorded a solo show in the Small Weston Room. Cuming, coming from the heart of the traditional Academy, contrasts with the featured artists of recent years: – David Hockney and Frank Stella. As Peter Blake remarks: 'The dedicated room for the last two years has been the Lecture Room, but that has been reclaimed as space and been given over to works on paper. In the Small Weston Room the featured artist can do whatever he or she likes. Fred Cuming has hung it as a beautiful one-man show.' Cuming was given six months to produce the exhibition. All but one of the twenty paintings – an early work from the 1950s – were completed during that time. That early painting, made while Cuming was a student at the Royal College, reveals that Cuming's attitude to painting was established early on. It sets the pace for this display, which, in a sense, shows Cuming's work coming full circle, whether he is painting his Sussex garden or the surrounding landscape, the soft tones of the coastal plain at Camber Sands, or Fowey in Cornwall under scudding clouds.

Frederick Cuming RA
The Granary, Rye (detail)
Oil
74 × 75 cm

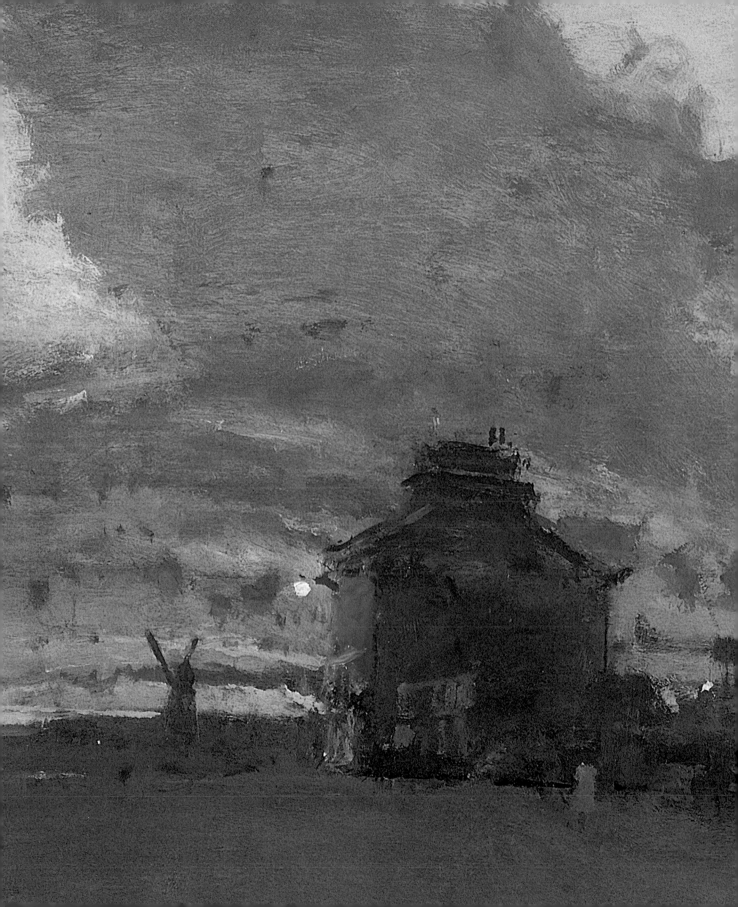

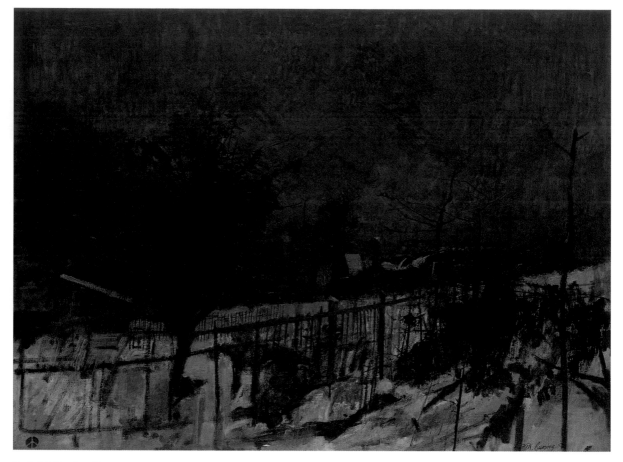

Frederick Cuming RA
Snow Scape and Thorn Tree
Oil
90 × 120 cm

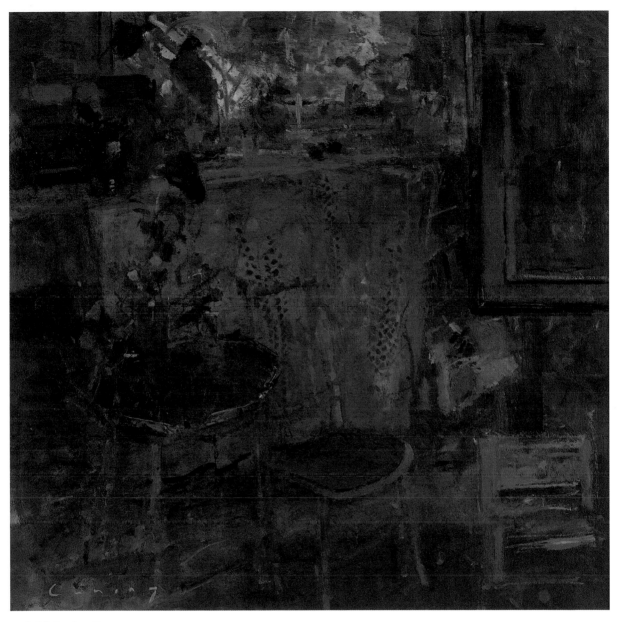

Frederick Cuming RA
Studio Autumn
Oil
75 × 74 cm

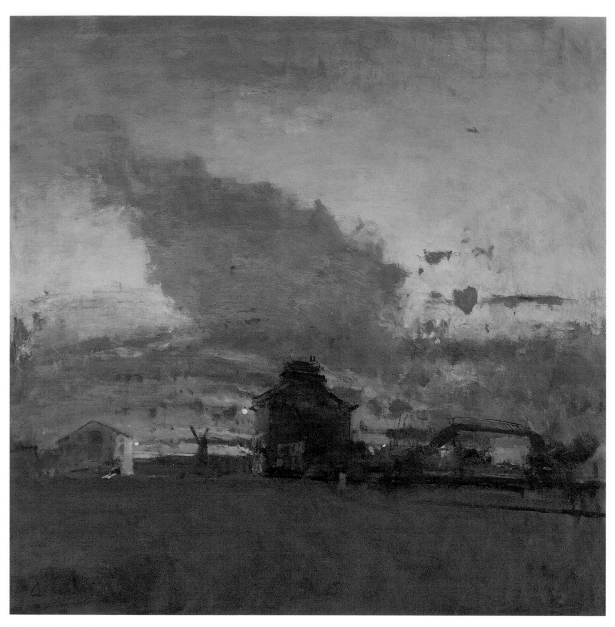

Frederick Cuming RA
The Granary, Rye
Oil
74 × 75 cm

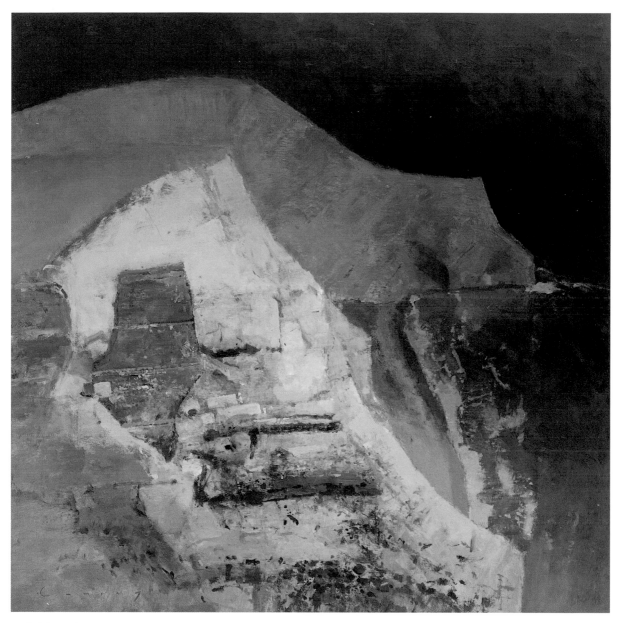

Frederick Cuming RA
Tennyson Down
Oil
89 × 89 cm

Gallery III

Gallery III, the largest gallery in the Academy, is traditionally a mixed hang dominated by Academicians. This year it contains only Members' work. Maurice Cockrill, making his first appearance on the Hanging Committee, worked with Allen Jones to hang the Members' work in this gallery, Gallery IV and the Wohl Central Hall. Did he feel the segregation of Members and non-Members was successful? 'I was one of the people who opposed it to begin with,' says Cockrill. 'Being only recently elected I thought that one of the reasons outsiders might send in to the Academy would be to hang among people they thought were successful professionals. But actually when it's done, and you see the RAs separated out from the non-RAs, both groups seem to benefit, because each is given more breathing space.' So how did this gallery come to be hung? 'Quite naturally the work seemed to fall into a kind of *War and Peace* opposition, with large abstract works down one side and mainly figurative works down the other. But there wasn't really a conscious aim to separate the two categories of work; it just seemed to come about that way – what fits with what. Could we put Leonard McComb next to Ken Howard? How would it work? It happens to work very well. On the other wall, large abstracts by John Hoyland, Sandra Blow and Bert Irvin seem to complement one another. This wall tends to be fairly high in colour, whereas on the opposite wall there's a wealth of detail and incidental interest. The end wall is organised around the central stack of Adrian Berg's paintings – to the left Colin Hayes and Sonia Lawson, and to the right Patrick Procktor and Terry Frost – in a complementary fusion of works. There's also a memorial display at the far end, to Ian Stephenson, whose work is shown to great advantage here. On the other side of the doorway Anthony Whishaw follows, with a group of paintings, full of character, which create a twilight, crepuscular world that is very convincing. It's quieter, and it takes longer to present itself to you; it doesn't hit you between the eyes like John Hoyland.'

Anthony Whishaw RA
Coppice III (detail)
Acrylic
168 × 390 cm

Prof. John Hoyland RA
Falls 28.3.2001
Acrylic
254 × 235 cm

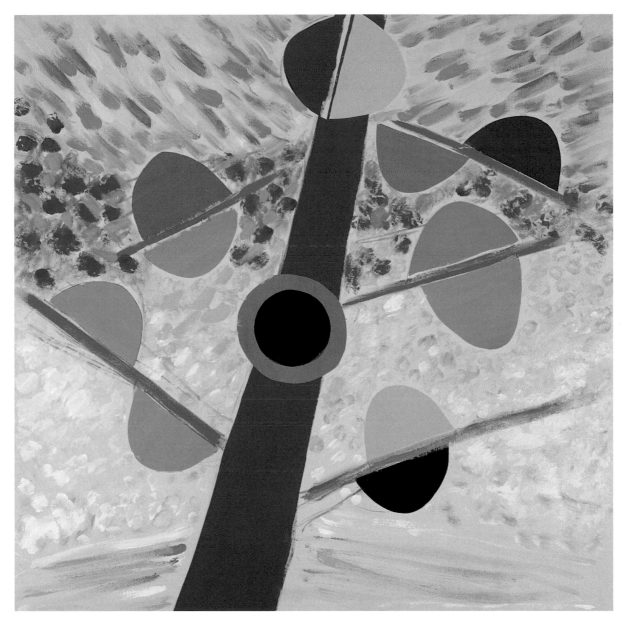

Sir Terry Frost RA
Cinnamon Tree
Acrylic
183 × 183 cm

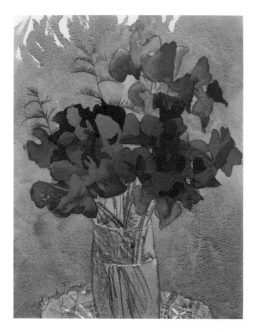

Patrick Procktor RA
Thistle II
Watercolour
30 × 22cm

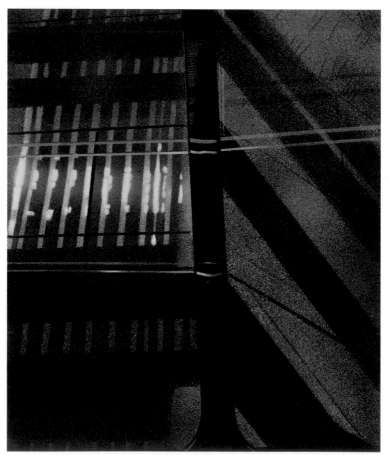

Prof. Brendan Neiland RA
Shadows
Acrylic
79 × 66 cm

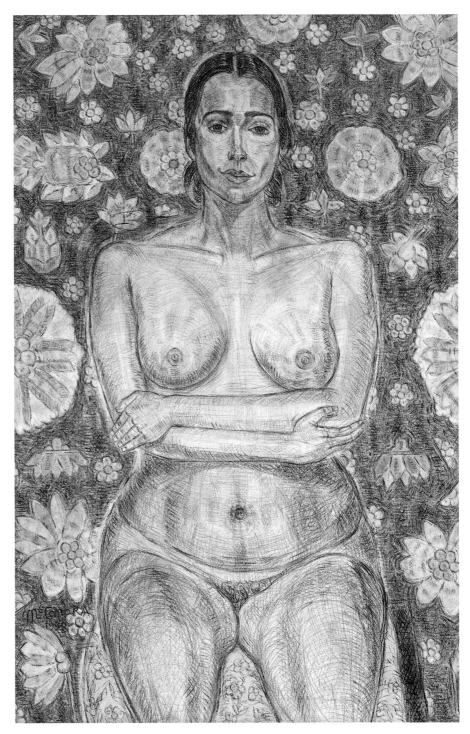

Leonard McComb RA
Portrait of Lucy
Mixed media
143 × 90 cm

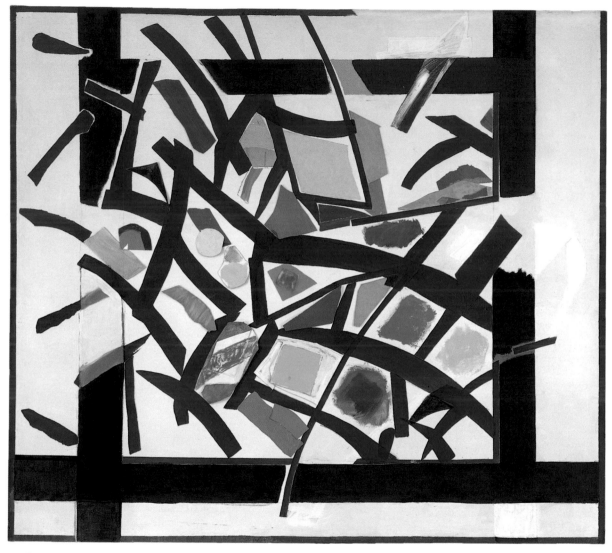

Sandra Blow RA
Counterpoint
Acrylic
244 × 274 cm

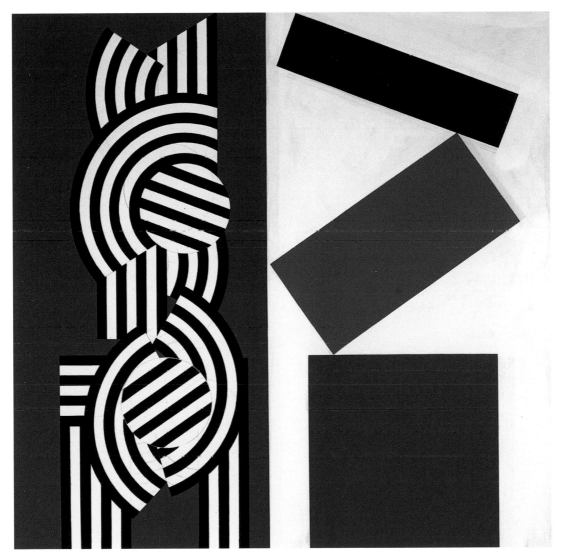

Prof. Paul Huxley RA
Anima Animus V
Acrylic
137 × 137 cm

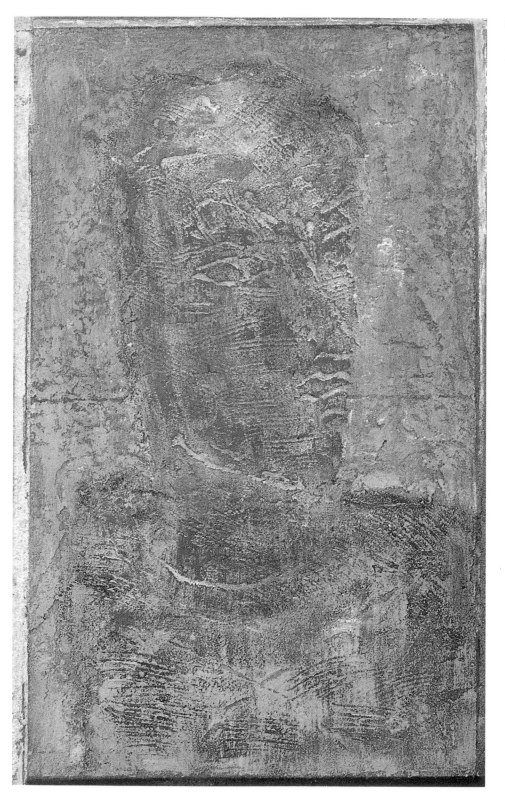

Sonia Lawson RA
Feel Free (detail)
Oil
121 × 91 cm

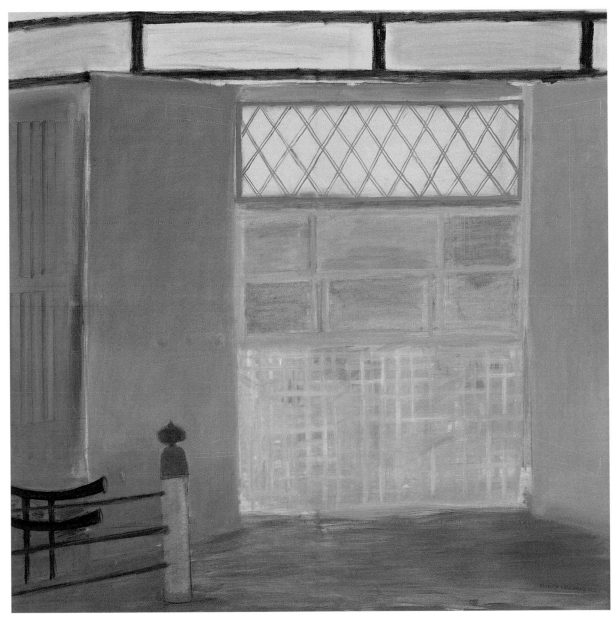

Elizabeth Blackadder OBE, RA
Doorway, Horyuji, Japan
Oil
152 × 152 cm

Albert Irvin RA
Noyna
Acrylic
214 × 305 cm

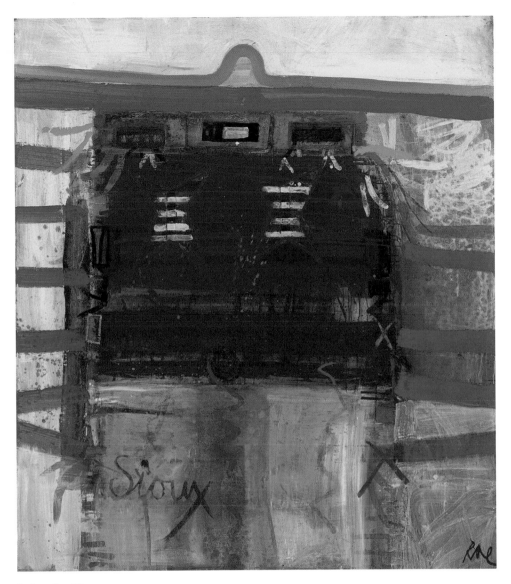

Barbara Rae RA
Sioux Blanket
Mixed media
229 × 198 cm

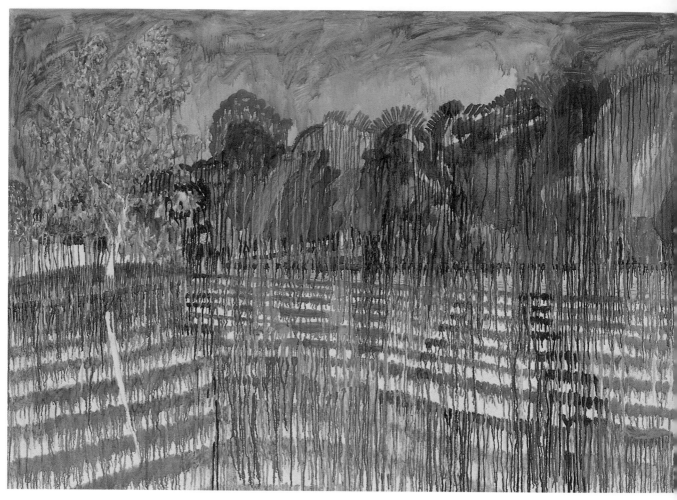

Adrian Berg RA
Stourhead 17th and 18th June (diptych)
Oil
133 × 375 cm

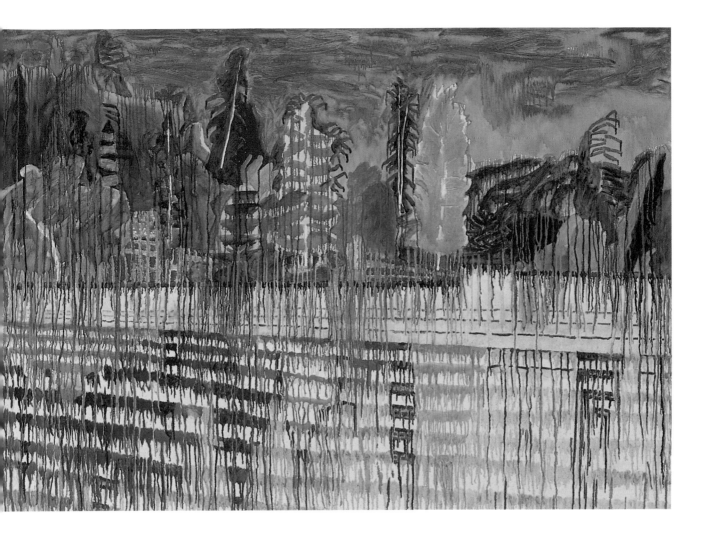

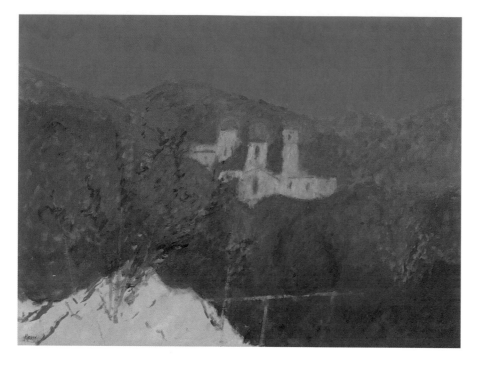

Colin Hayes RA
Church in Western Crete
Oil
75 × 100 cm

Ian McKenzie-Smith
Ziggurat, Island
Oil
106 × 126 cm

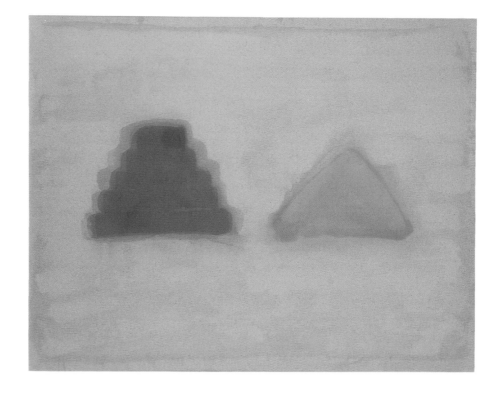

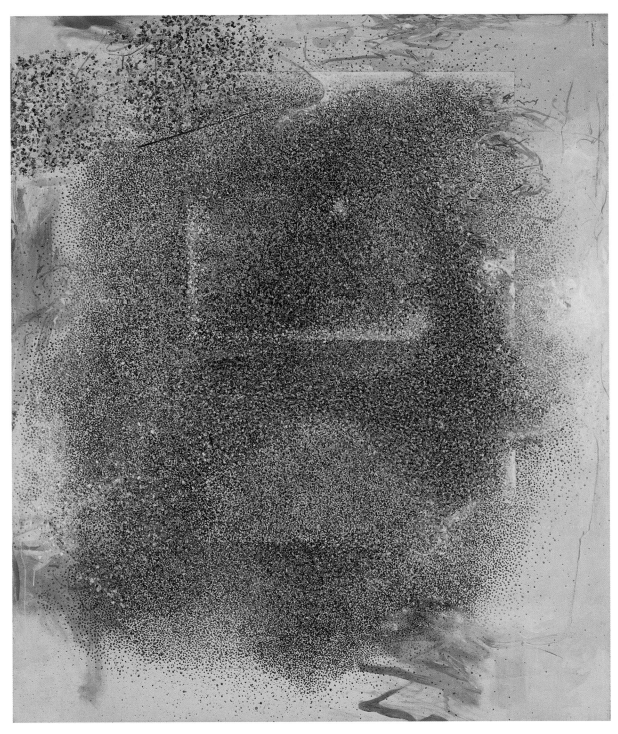

Ian Stephenson RA
Elapse
Oil
123 × 103 cm

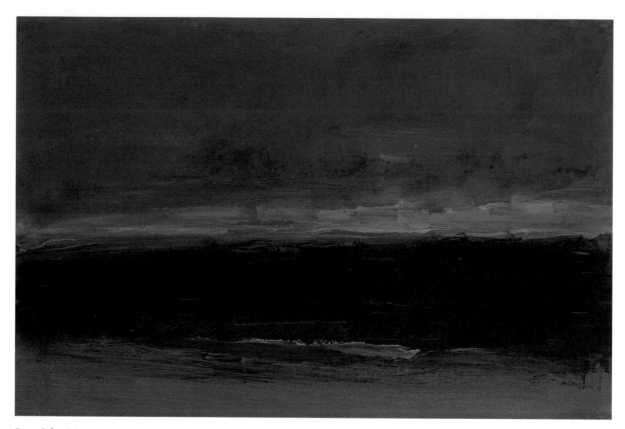

Peter Coker RA
North Sea
Oil
71 × 104 cm

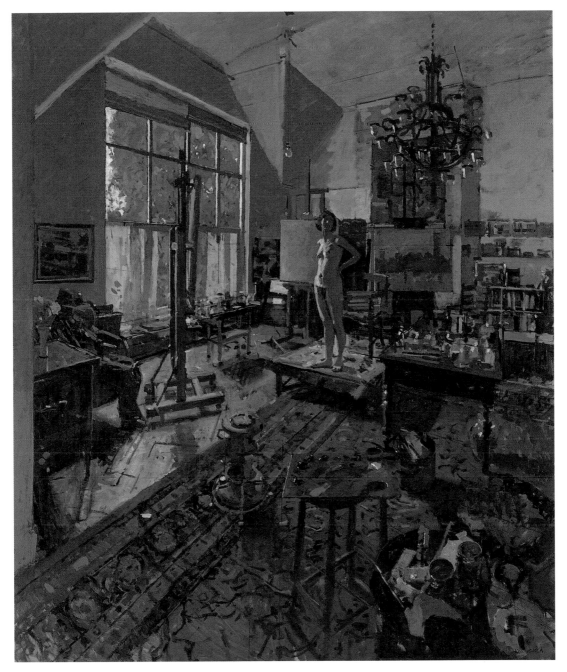

Ken Howard RA
The Studio 2001
Oil
182 × 153 cm

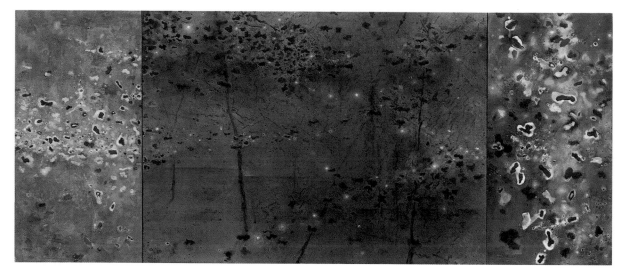

Anthony Whishaw RA
Coppice III (triptych)
Acrylic
168 × 390 cm

Ivor Abrahams RA
Acrobats (detail)
Bronze
H 21 cm

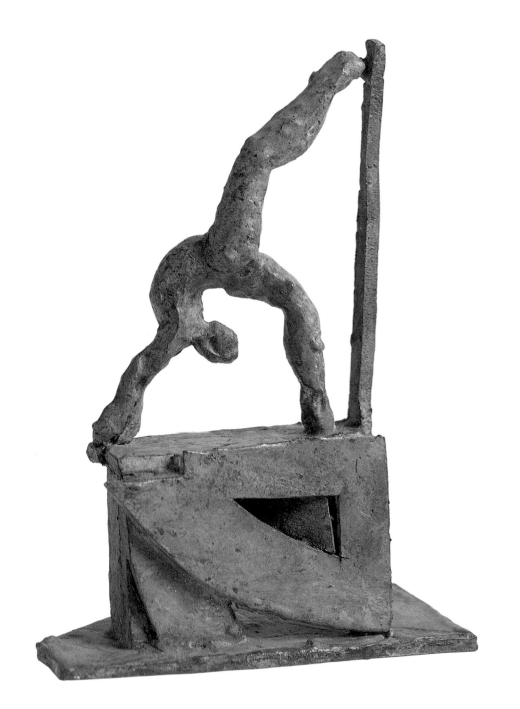

Mick Moon RA
Still Life I
Monoprint
150 × 200 cm

Gus Cummins RA
Circus II
Acrylic
172 × 239 cm

Gallery IV

This is the second of the three galleries devoted solely to Members' work. Chief among the paintings is a large diptych by Allen Jones depicting a dream landscape with waterfalls and lovely naiads. As Maurice Cockrill remarks: 'With powerful paintings that you find attractive – say a Matisse or Pollock – a world is presented that you want to be part of. This painting has that kind of feel.' Two Peter Blake figure paintings dominate the wall which also displays a large Crucifixion and a tiny painting of a fragile flower in a glass by Craigie Aitchison. In the corner position, in a similar location to Ian Stephenson's paintings in Gallery III, there's another memorial display. This commemorates the work of Ken Kiff, with a representative selection of drawings, paintings and prints, showing both his considerable graphic skills and his gift for colour. 'It's the first thing you see coming into the gallery,' comments Cockrill. 'There's a very fine painting, some strong prints and a beautiful drawing from his National Gallery days. Normally there would be a maximum of six pieces, but that didn't seem to be sufficient to represent Kiff entirely in the round, so we borrowed three more prints to make a cohesive group.' 'Over there', continues Cockrill, 'is one of the best displays of Mick Rooney's work I've seen, very strong pictures, well related and hung together.' The gallery is notable also for its use of blank space – for instance on the wall surrounding Blake's *Black Woman (Detail After a Painting in the National Gallery, London)*; in previous years such space might well have been filled in with paintings 'skied' towards the ceiling. Meanwhile, the floor is powerfully articulated by John Maine's Brazilian granite stone circle, like a section through a lighthouse, and David Nash's vaulting wooden sculpture.

Tom Phillips's stitched coverlet of prostitutes' calling cards raises a very current issue, in the light of recent suggestions that the placing of these cards in telephone boxes should be regarded as a criminal offence. Perhaps appropriately, a tall statuesque nude, seen from behind and drawn on canvas by Kitaj, hangs nearby.

John Maine RA
Clava (detail)
Graphite
H 47 cm

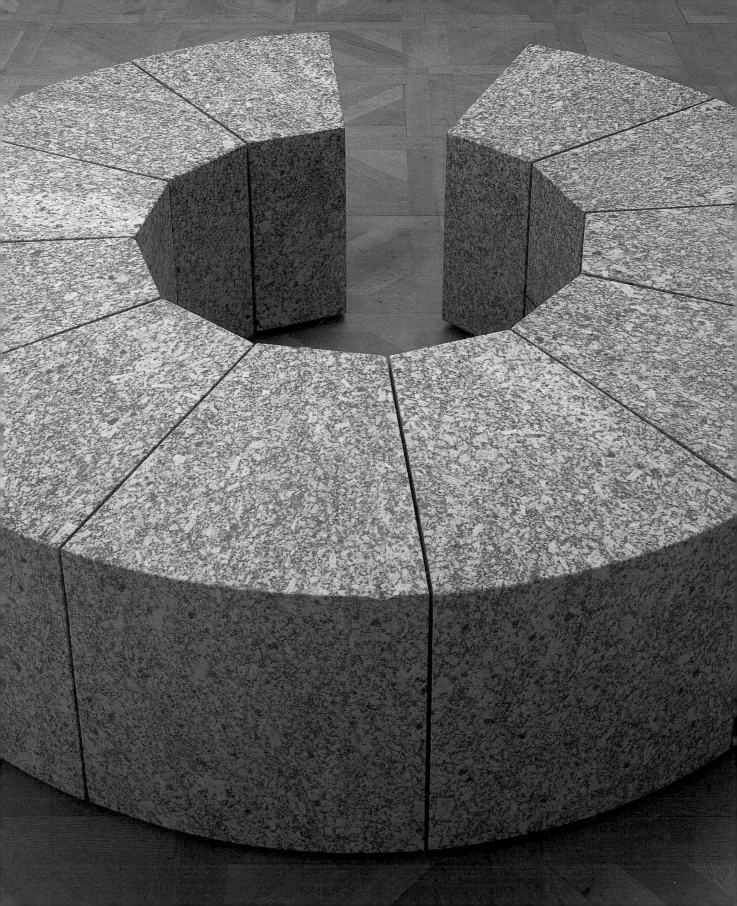

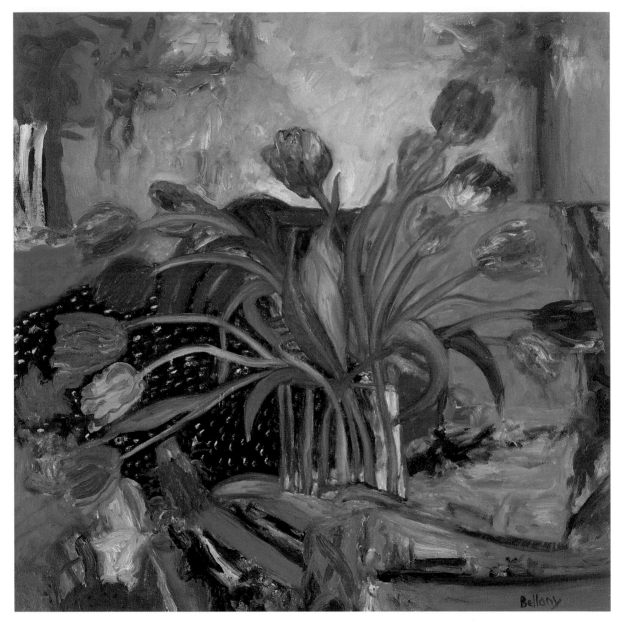

Dr John Bellany CBE, RA
Our First Tulips
Oil
90 × 90 cm

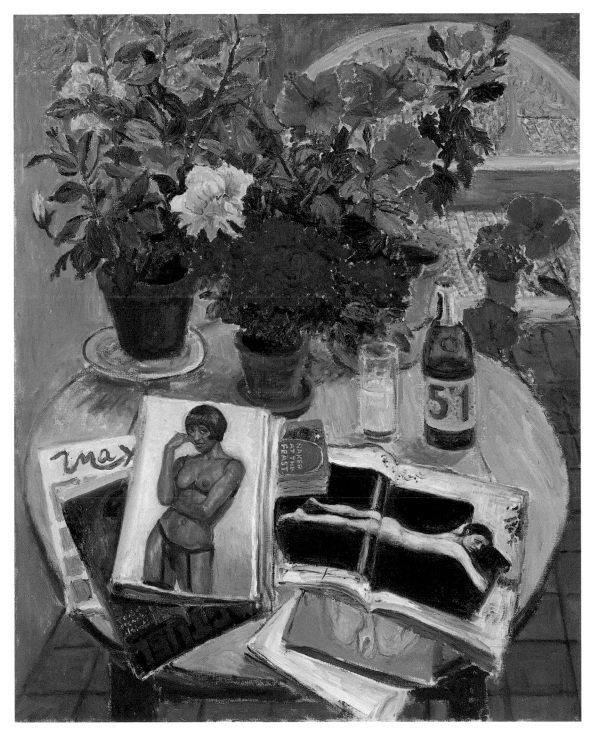

Frederick Gore CBE, RA
Naked at the Feast
Oil
126 × 101 cm

Mick Rooney RA
The Naturalists
Oil
113 × 75 cm

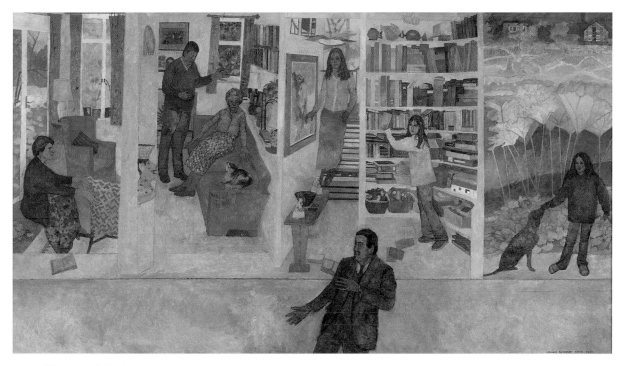

Leonard Rosoman OBE, RA
From the House into the Garden
Acrylic
121 × 212 cm

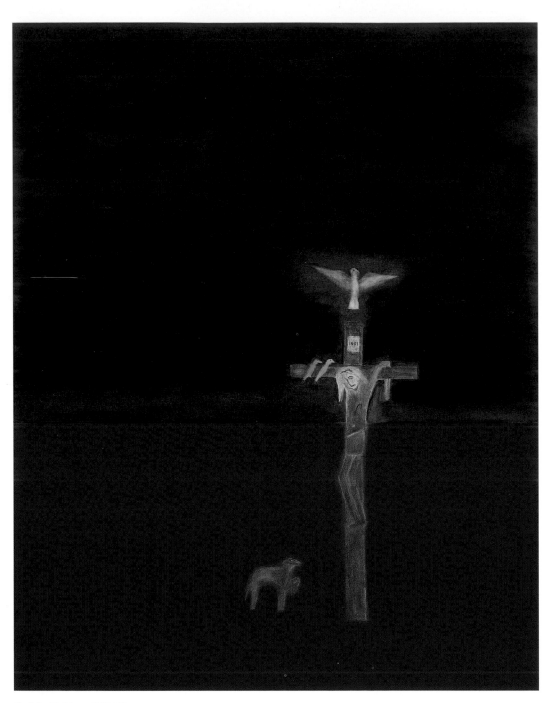

Craigie Aitchison CBE, RA
Crucifixion
Oil
142 × 113 cm

Ken Kiff RA
After Patenier (1), 1992
Charcoal and pastel
107 × 103 cm

Allen Jones RA
Cascade (diptych)
Oil
229 × 304 cm

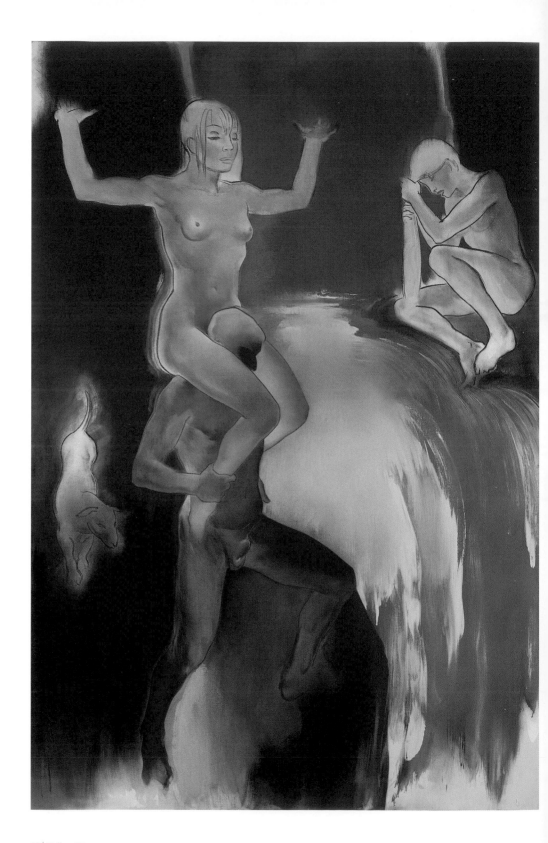

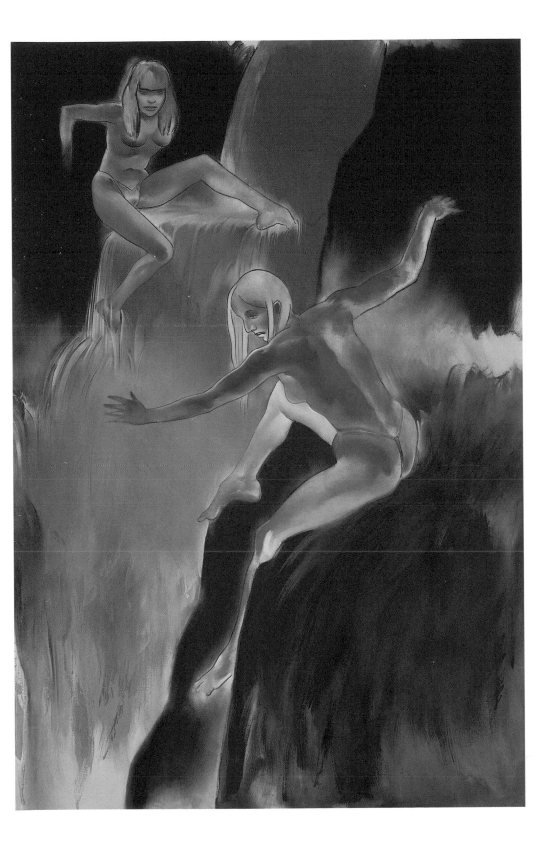

David Nash RA
Vessel
Oak
H 214 cm

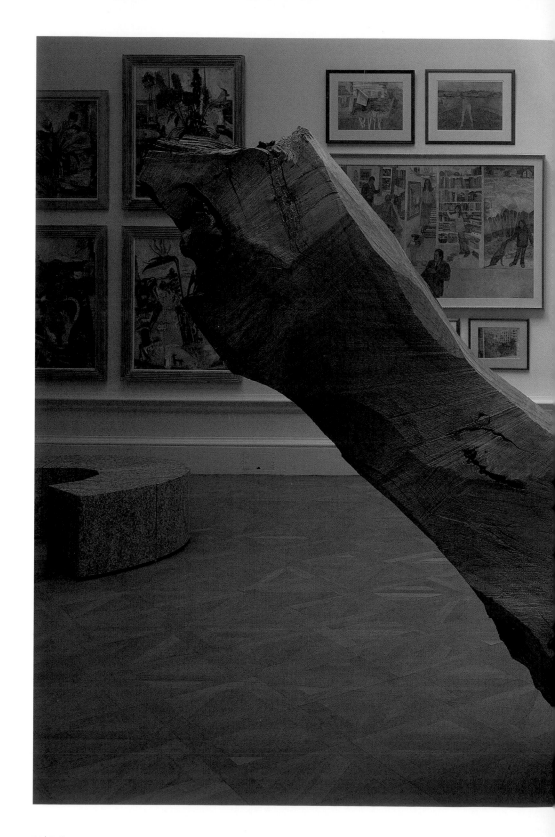

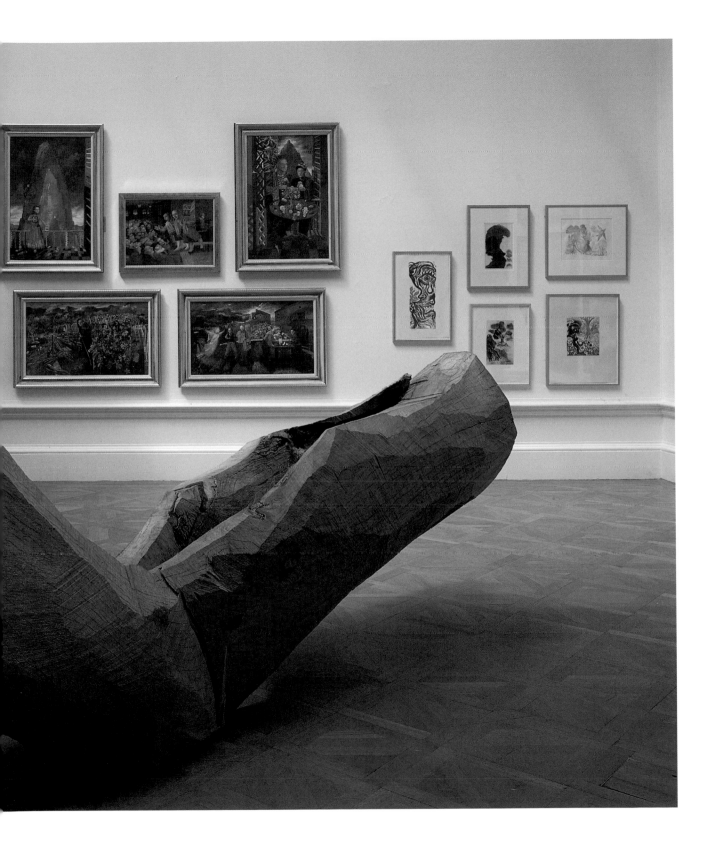

RB Kitaj RA
Braiding Hair
Charcoal
192 × 43 cm

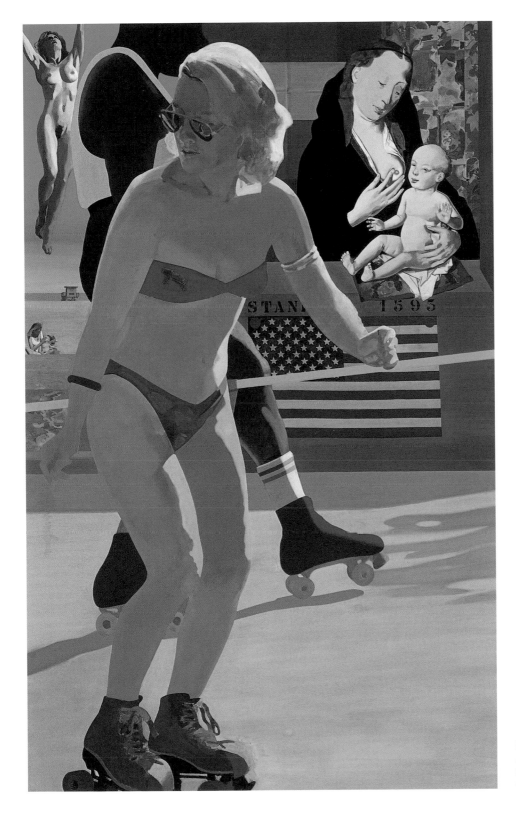

Peter Blake CBE, RA
Madonna of Venice Beach
Oil
132 × 82 cm

Gallery V

This gallery, hung by Sonia Lawson, is the first of three entirely devoted to work from open submission. Towards the middle of the gallery crouches a massive Corten and steel head of Alfred Hitchcock by Antony Donaldson, its chin hitting the floor. Its dark shape sets off the paintings and the austerity of their hang. 'You can't really have a theme when you don't know what's coming in and what you'll be able to choose,' says Lawson, 'but you can in the end decide that you want to keep it as uncluttered as possible. The paintings are predominantly abstract, and that in itself seems to be fairly liberating. I didn't want to be involved with what might turn out to be like a Spanish salad – a bit of this, a bit of that. I think I've got a kind of clarity in here. There's still variety, but there's a cohesiveness to the room.' Lawson didn't know many of the artists she hung, although several are former students of the Royal Academy Schools whose names she recognised but whose work has changed and developed. There's a strong element of what might be called the School of Tunbridge Wells (where Roy Oxlade and his wife Rose Wylie taught for many years), with a luminous orange painting by Georgia Hayes as its centrepiece. A large drawing of piled up wrecked vehicles holds the wall nearby. 'With my own work I like it to work from a distance as an abstract, contemplative thing, and then when you go closer you can see graphic things happening, and this works similarly,' says Lawson. Is hanging a gallery like this all a matter of compromise? 'I wouldn't say I'd compromised at all – I'm quite happy with what I picked out from the send-in.'

Antony Donaldson
Master of Suspense
Corten and steel
H 112 cm

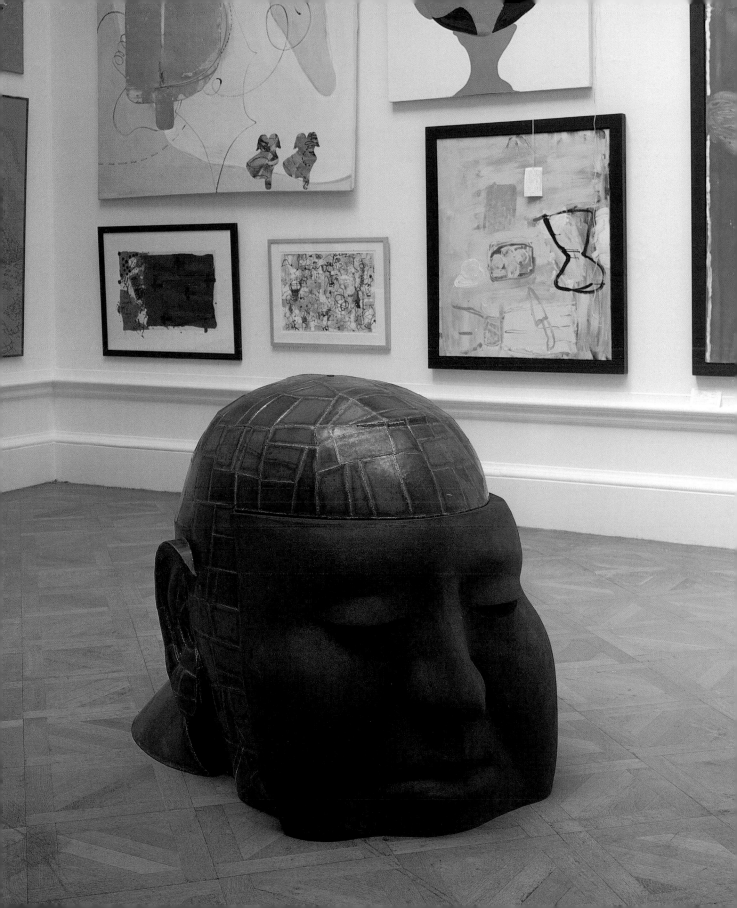

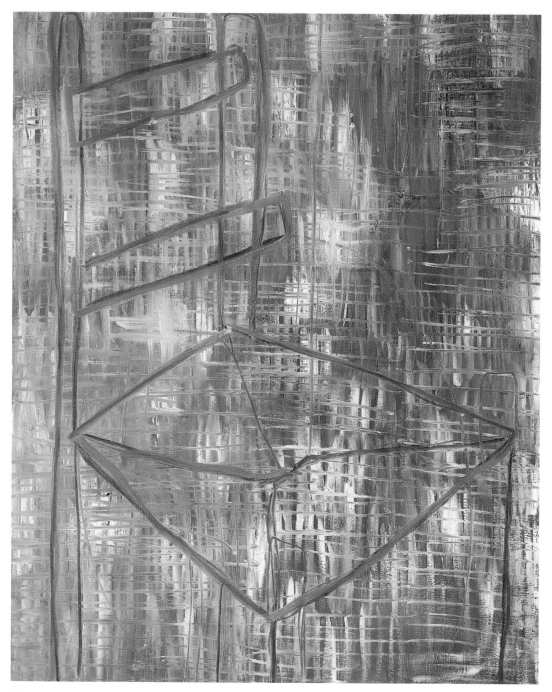

Cleland Moore
Chair on Grid
Oil
152 × 121 cm

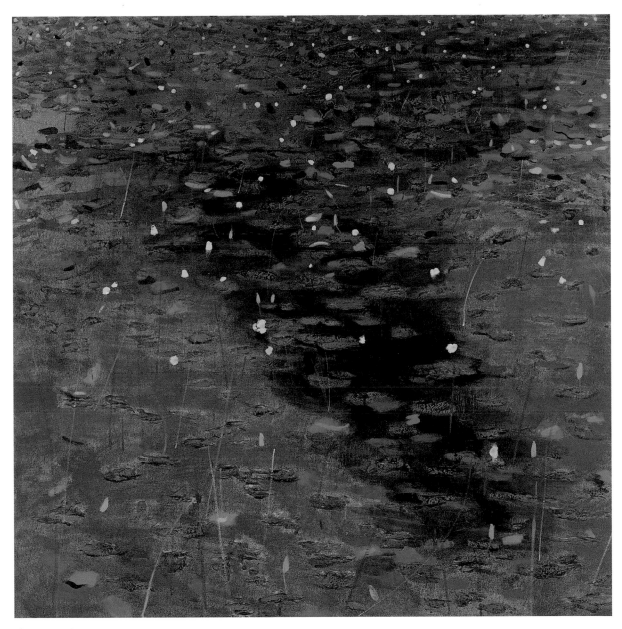

Alex Hamawi
Waterlilies
Oil
148 × 148 cm

William Bramer
Grey Mist
Etching
121 × 85 cm

Kwai Lin
Returning to Lamay (Part II)
Oil
18 × 23 cm

David Leapman
Conquest
Acrylic
60 × 50 cm

Vatcharin Bhumichitr
Flame
Screenprint
76 × 76 cm

Hugh O'Donnell
A Process in the Heart – The Green Unraveller
Oil
35 × 32 cm

Daniel Lewis
Intitled Cars 2
Oil
167 × 182 cm

Brian Waterson
Elsie May's Sky
Oil
120 × 152 cm

Georgia Hayes
Hung, Drawn and Quartered
Oil
175 × 182 cm

Gallery VI

Hung by William Bowyer, this gallery celebrates the deeper traditions of contemporary British painting, covering some of the ground common to the New English Art Club, for instance. Bowyer began very simply, by laying out the long north wall of the gallery. 'I've given everybody a fair crack of the whip, both young and old alike, providing their work is vital and alive.' Bowyer identifies no particular theme among the works he has hung, aside from differences in paint quality. 'There are quite a few landscapes and abstract still-lifes, but I feel it's a room that has warmth and is well-balanced.' Among the landscapes are two London river paintings, vertical in format and richly heaped with pigment, by George Rowlett. A pastel-tinted Irish landscape, with a surface of exquisitely rucked impasto which actually functions as drawing, is by the professor of painting at the Royal College of Art, Graham Crowley. Two subtle, green garden pictures by Eileen Hogan explore the threshold between indoors and out. And in the middle of the room sits a ten-piece cast-paper sculpture by Glynn Williams, a still-life composition cut into chunks. Bowyer has hung examples of hard-edge and organic abstraction with representational work. He has an eye for monumental qualities in modest paintings, and his style of hanging is noted for the virtues of restraint and solidarity.

George Rowlett
Canary Wharf, Morning Crane Dance (detail)
Oil
93 × 47 cm

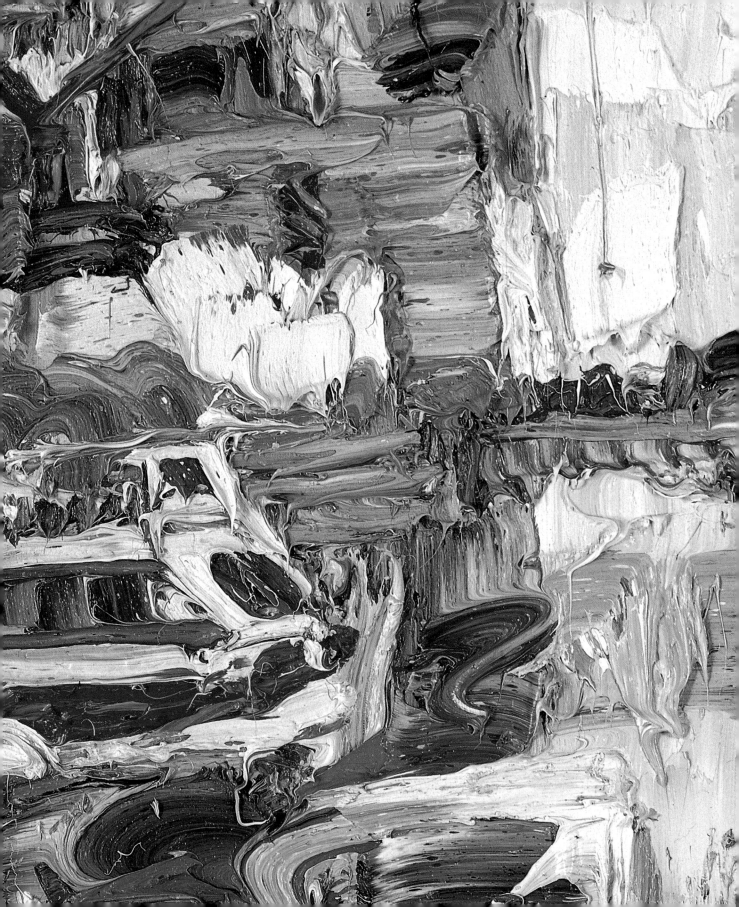

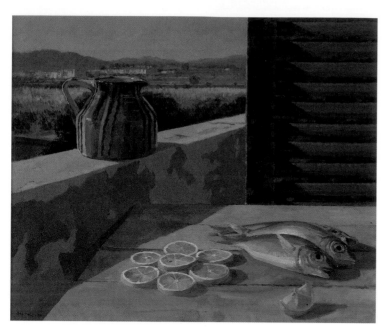

John Morley
Still Life – Sea Bream
Oil
36 × 45 cm

Arthur Richard Neal
Studio Table
Oil
61 × 66 cm

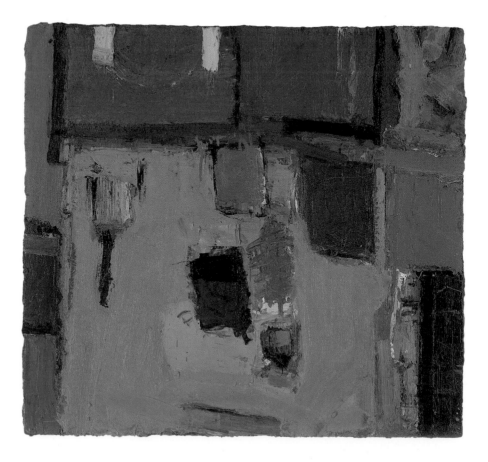

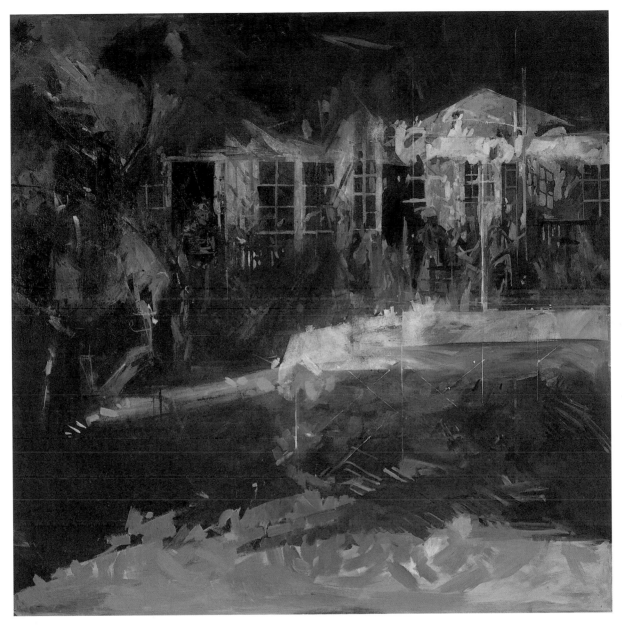

Eileen Hogan
Chelsea Arts Club
Oil
121 × 121 cm

George Rowlett
Canary Wharf,
Morning Crane Dance
Oil
93 × 47 cm

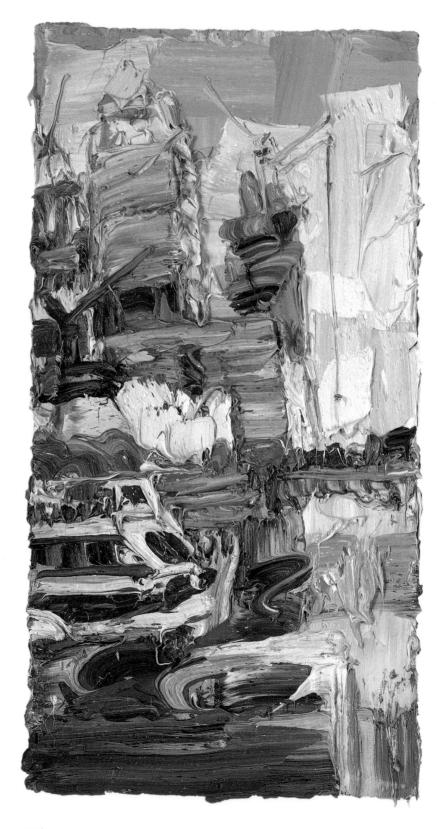

Geri Morgan
Olive Oil Bottle Still Life
Oil
44 × 35 cm

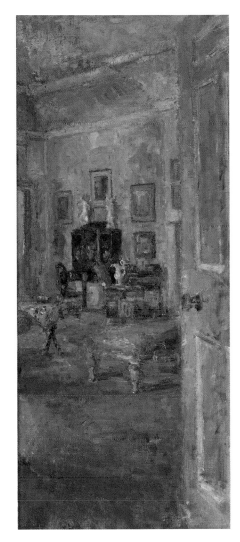

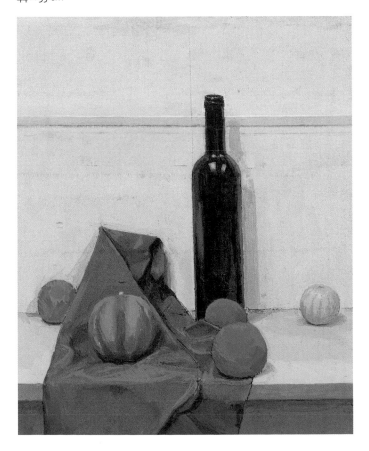

Edward Fairfax-Lucy
Room with Blinds drawn
Oil
50 × 20 cm

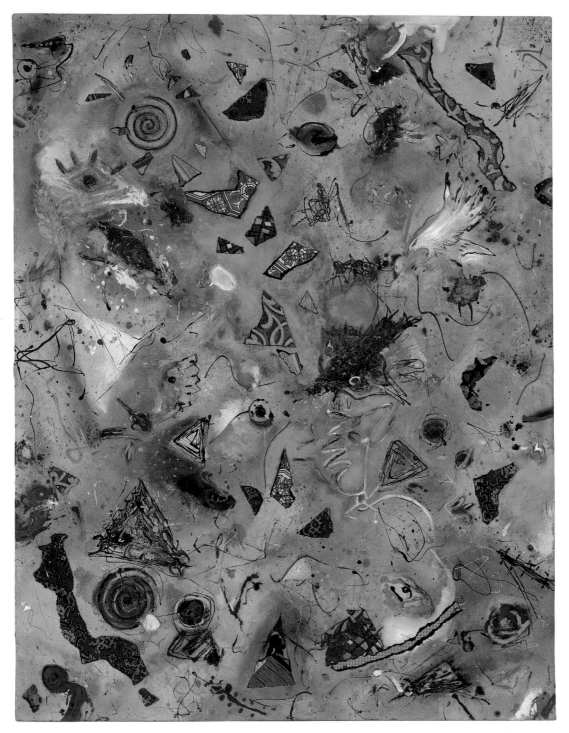

Michael Ward
The Gift
Oil
210 × 163 cm

Rachel Heller
Model 2001
Oil
107 × 91 cm

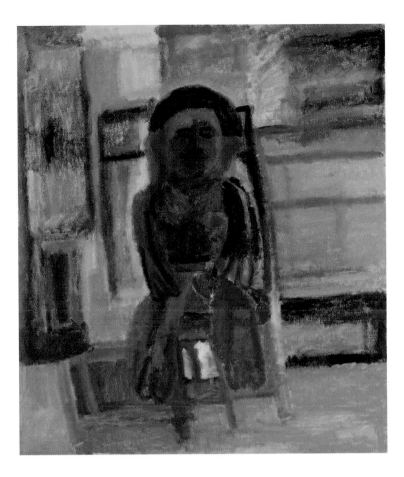

Susan Bower
Riding by
Oil
36 × 39 cm

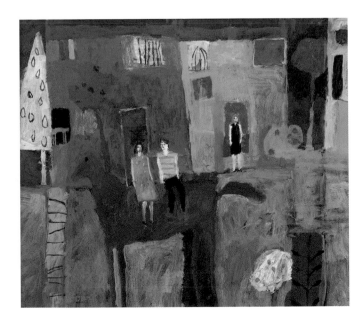

Gallery VII

This gallery of non-Members' work was hung by Mick Rooney, the first time he has had sole responsibility for a room. 'I've taken on board all the narrative, figurative drawing, and the representational with very little abstraction. Certain themes seemed to emerge: there are a lot of heads and portraits on one wall. We've got scale as well – very large paintings down to miniatures. We've got every kind of medium, so you'll find drawings, tempera paintings, oil paintings, charcoal, Conté crayon, acrylic. We've tried to hang some frenetic paintings by surrounding them with quieter things. And works of illusion on one wall, like the Patrick Hughes and the *trompe l'oeil* picture near it of black-and-white photographs of Vermeer paintings stuck on a wall. In order to make the Hughes work, we surrounded it with industrial landscapes. A lot of it is to do with refining ways of putting pictures on the wall. Then there are beautiful watercolours by someone who lives in Paris, Nina Danilenko Another painting was brought by hand from Florence. We've tried to plan it so that there is peace between pieces, so to speak. There's a narrative in the room, but it's not deliberate because things find their place. The story, if there is a story, has its own thrust, you don't pre-invent it. You don't write it down as a script. Actually it flowed slowly and hung itself really. Take Shanti Panchal. Because of the way the Summer Exhibition has been organised this year he has a chance to hang in a central spot. Normally an RA would have that spot, if the gallery was a mixed hang. Some of the better non-Members' works can be shown very well, with a great deal of dignity, for instance, the very fine Victor Newsome tempera painting. I hope people see a kind of textural broadness throughout, and that in the middle-ground of painting there are thousands of ways of painting a picture. And if they are the best of their sort they tend to revalidate the business of painting.'

George Underwood
Just Nine Men (detail)
Oil
59 × 42 cm

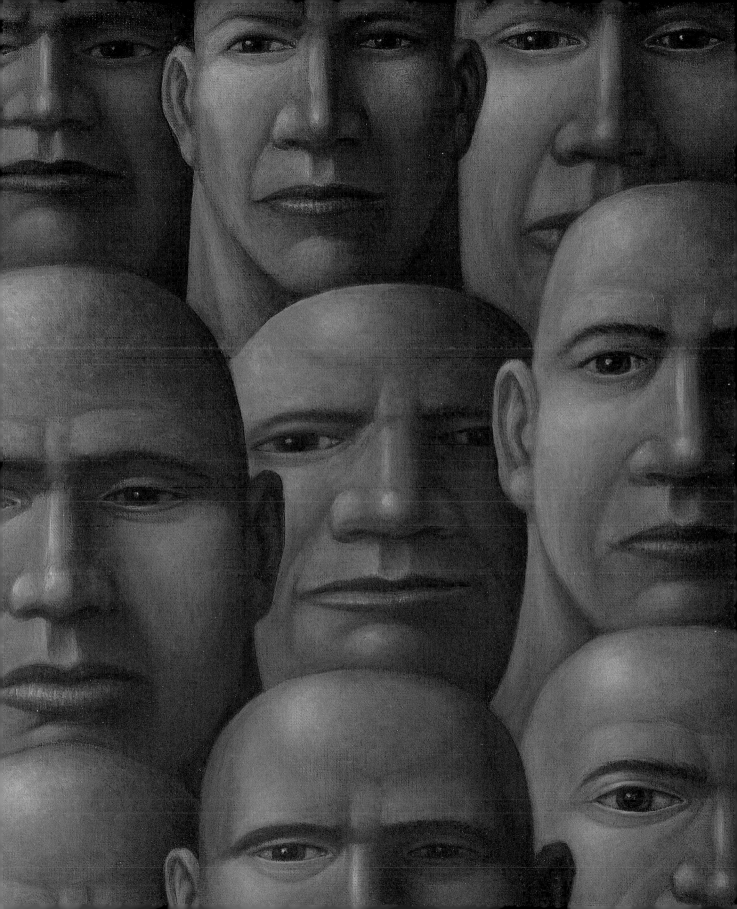

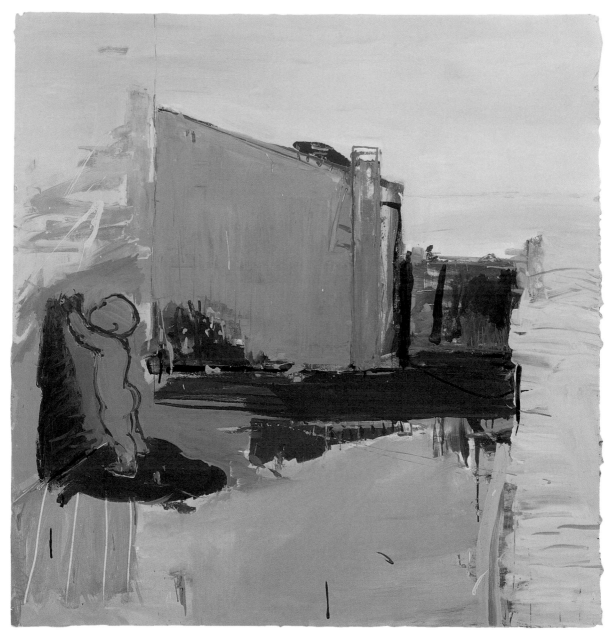

Lisa Wright
Shadow Walking
Mixed media
100 × 100 cm

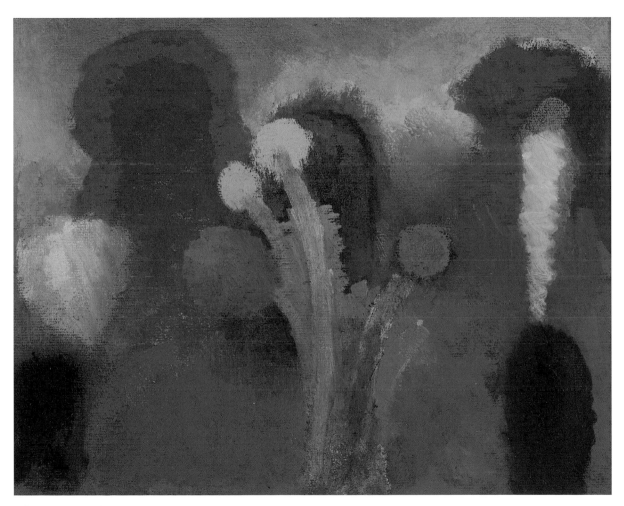

Alfred Francis Stockham
Poetsgarden II
Oil
19 × 24 cm

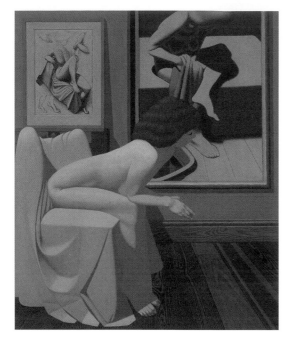

Victor Newsome
Actress Modelling in my Studio III
Egg tempera
108 × 90 cm

Antony Williams
Teasle with Large Bag
Tempera
118 × 82 cm

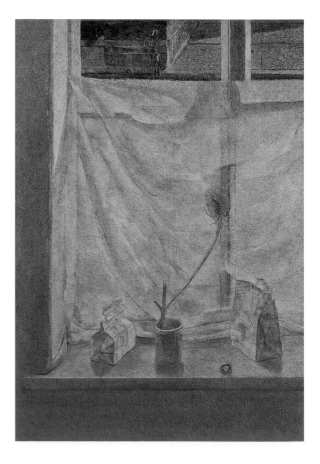

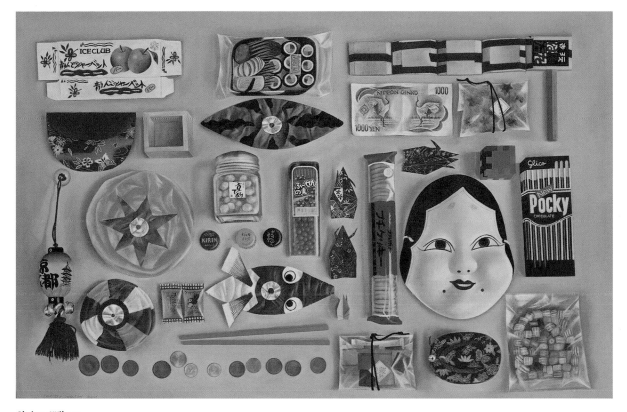

Chrissy Wilson
Japanese Still Life
Oil
59 × 95 cm

Paul Becker
Die
Oil
38 × 38 cm

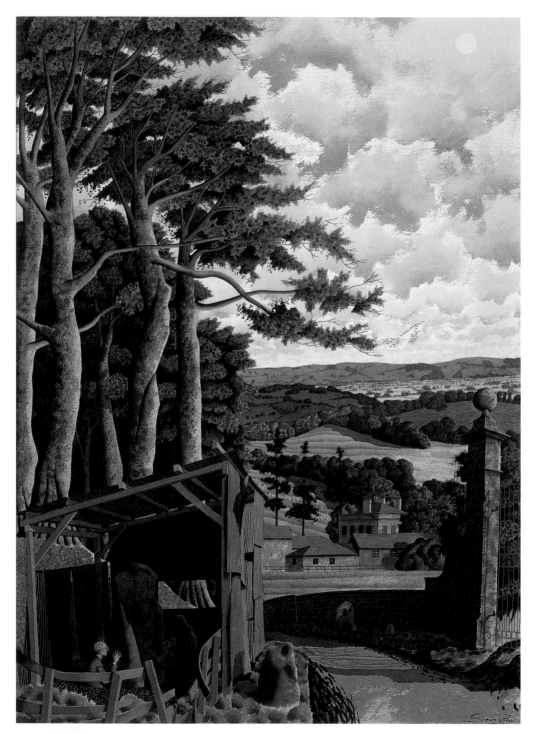

Simon Palmer
Archaeological Excavations
Watercolour
91 × 65 cm

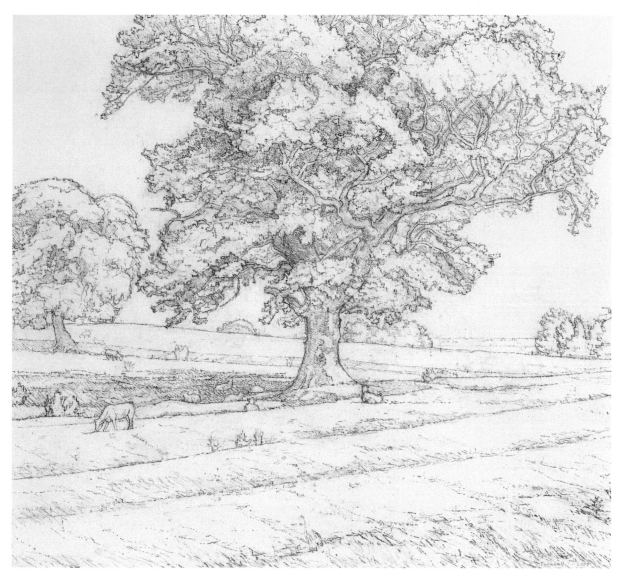

Alan Turnbull
Summer Oak
Charcoal
55 × 58 cm

Peter Kelly
Christina
Oil
28 × 20 cm

Peter Fleming
Annunciation
Egg tempera
16 × 14 cm

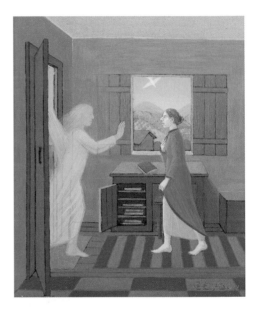

Jane Bond
Night Voyage
Oil
13 × 14 cm

Bronwen Malcolm
The Bride
Oil
22 × 28 cm

James Kirkman
Day of the Dead
Oil
57 × 50 cm

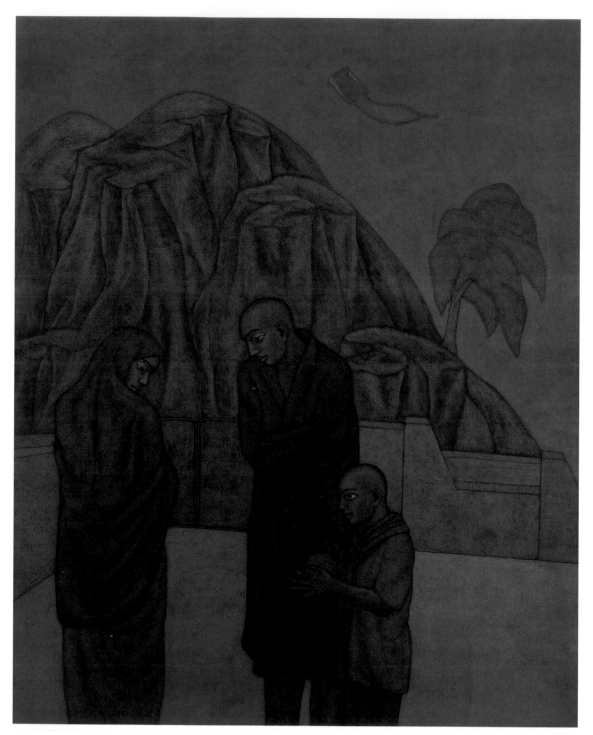

Shanti Panchal
The Tragedy, after Picasso
Watercolour
150 × 122 cm

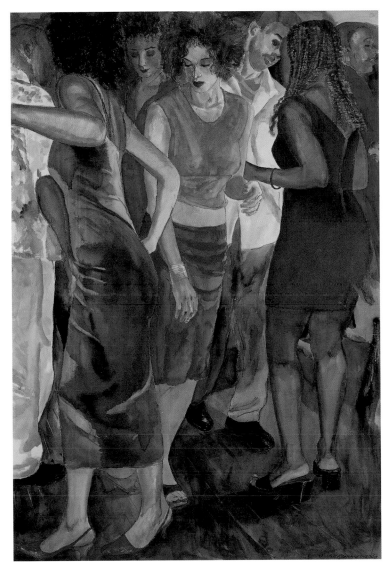

David Remfry
Party
Watercolour
151 × 103 cm

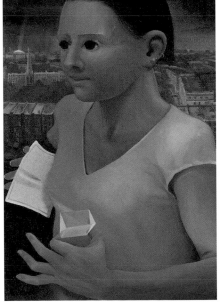

Dennis Geden
Rainbow at Earl's Court
Oil
46 × 31

Gallery VIII

The sculpture gallery has been hung this year by Richard Deacon, his first selection and installation of exhibits at the RA. Inevitably, not everything that he selected could be fitted in, given the size of the striking alabaster piece by Anish Kapoor and the sliced marble column (which turns into the profile of a face as you move around it) by Tony Cragg. 'I've tried to draw a part of the hang from open submission, not just from Members,' says Deacon. The walls are largely bare, except for a lively, large print by Ivor Abrahams and two collages by David Mach. Alone and high up on the far wall are positioned two small sculptures in polished steel and ink on Japanese paper by Alison Wilding. 'I think Alison makes the wall very active. If you start putting other things on it as well, it kills that use of the wall as a space.' On the adjacent wall, also high up, hangs a sculpture from open submission made from human hair by Claudia Torres, which is juxtaposed beautifully with the Wildings. An Allen Jones mannikin, clad in close-fitting *café-crème* and lemon-yellow leather, stands proud on a stainless-steel base. Deacon's own sculpture is also a solid floor piece, in glazed ceramic, with tongues of flame or organic fronds. There's a tiny towering assemblage of figures by Peter Blake (which relates interestingly to the Tony Cragg) and a floored bronze dung beetle by Wendy Taylor. The range of work, which includes a wildly kitsch *mélange* of shells, mirror, statuettes and chopsticks by Andrew Logan, and an elongated fibreglass head by John Patrick Humphreys of Mick Fleetwood (like an anamorphic portrait), is a tribute to Richard Deacon's frame of reference and to his understanding of the meaning of the Summer Exhibition.

Andrew Logan
The Mountain (detail)
Mixed media
H 202 cm

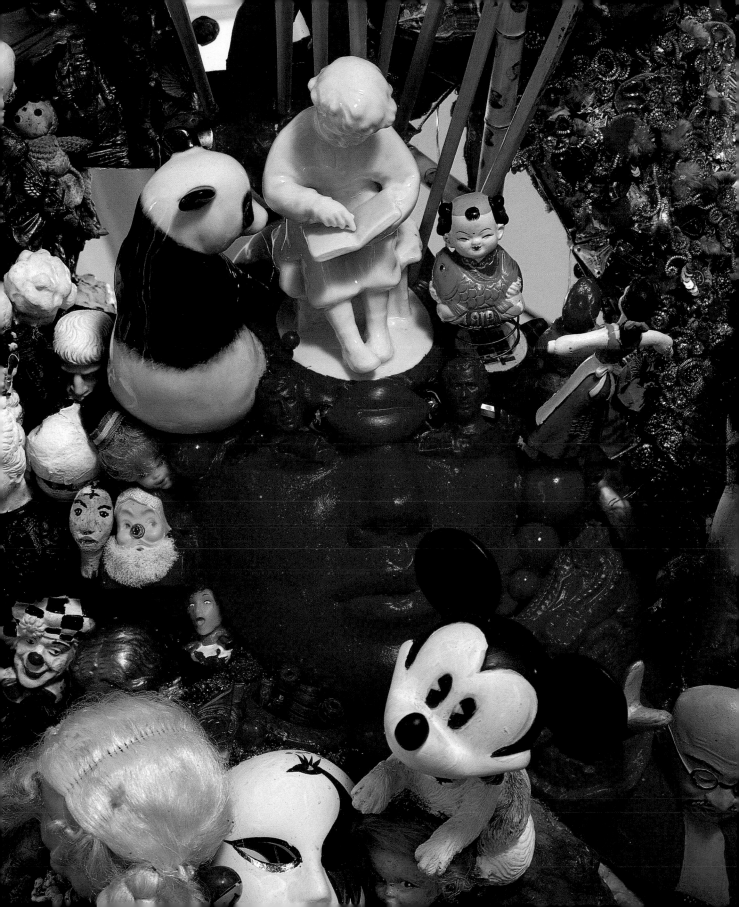

Alison Wilding RA
Stealth I
Mixed media
H 15 cm

John Patrick Humphreys
Mick Fleetwood
Fibreglass
H 63 cm

Alan Fletcher
Menagerie of Imaginary Creatures (detail)
Mixed media
H 23 cm

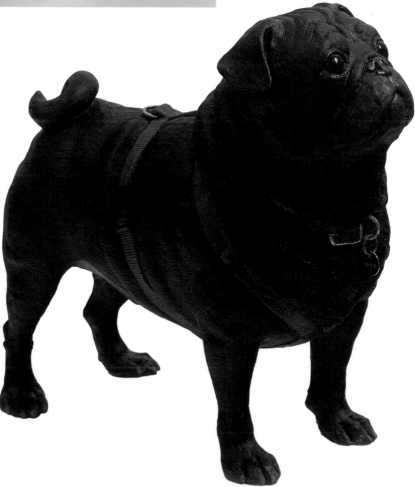

Cathie Pilkington
John
Bronze
H 37 cm

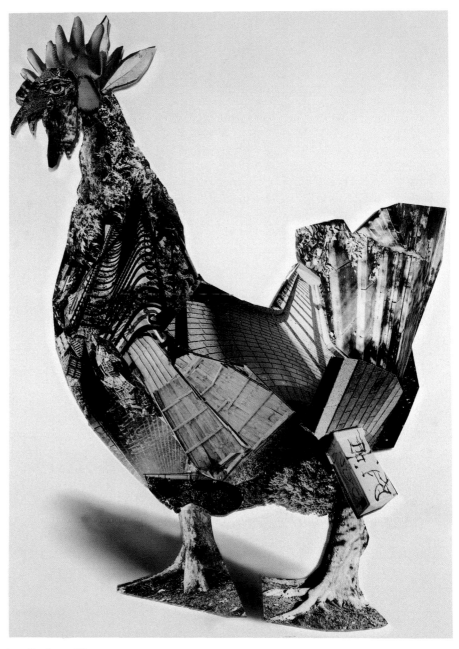

Ivor Abrahams RA
Cock
Digital print
129 × 92 cm

Peter Blake CBE, RA
4 Men up
Mixed media
H 73 cm

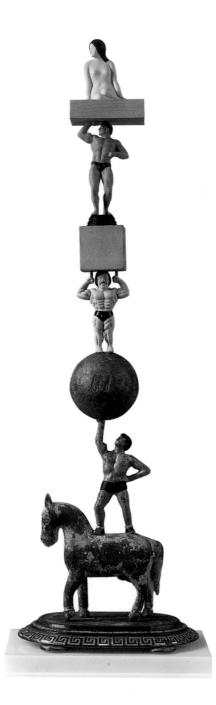

Prof. Tony Cragg RA
One Way or Another
Giallo Sienna marble
H 225 cm

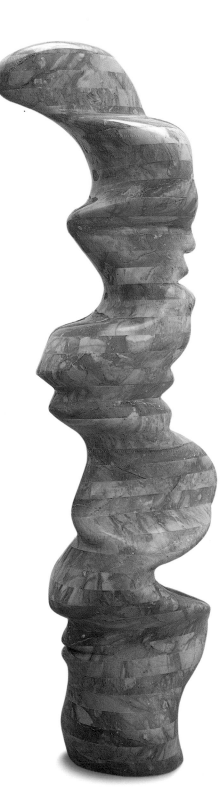

Brian Falconbridge
White Clouds Dark Smoke VI
Bronze
H 11 cm

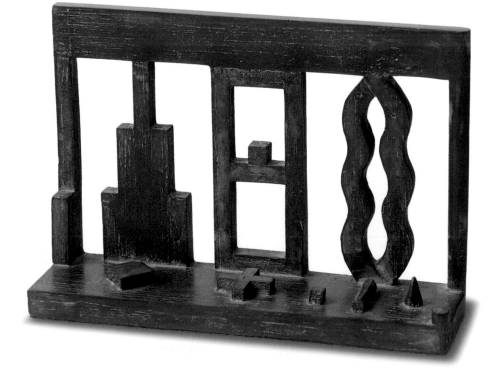

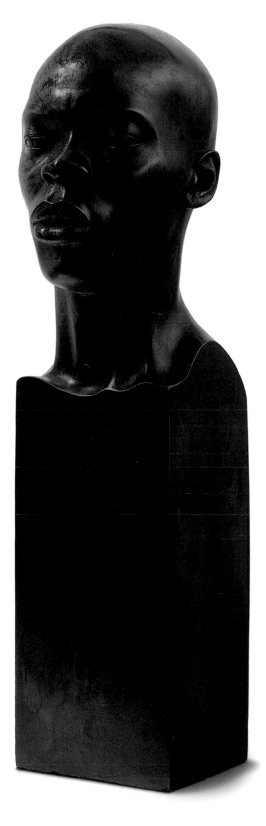

Fowokan George Kelly
Of the Will of Ogun
Iron and resin
H 62 cm

Richard Deacon CBE, RA
Tomorrow, and Tomorrow, and Tomorrow
Glazed ceramic
H 130 cm

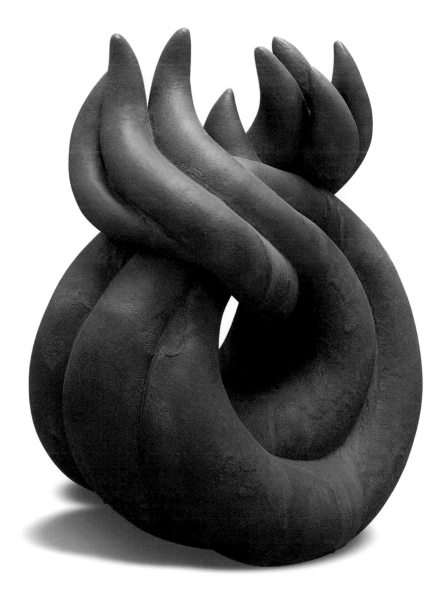

Anish Kapoor RA
Untitled, 1999
Alabaster
H 156 cm

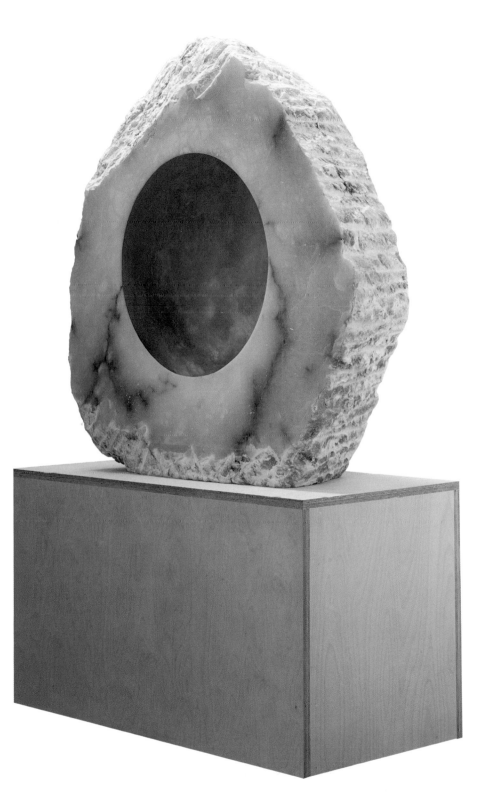

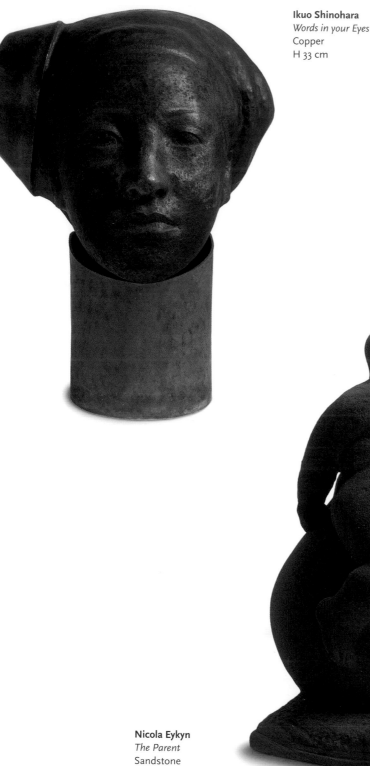

Ikuo Shinohara
Words in your Eyes II
Copper
H 33 cm

Nicola Eykyn
The Parent
Sandstone
H 22 cm

Prof. David Mach RA
Bridging the Gap
Collage
113 × 221 cm

Gallery IX

Michael Manser has hung the architecture gallery this year, with Nick Grimshaw. The general public doesn't always find it easy to understand architects' drawings and models, so this year an attempt has been made to address the problem. 'The drawings and their captions need to be seen close to, so we have tried to make a band around the room about a metre high above the wainscot where all the smaller drawings and more intricate things are collected,' says Manser. 'Generally speaking we've managed to achieve that, with the bigger schemes which are self-explanatory higher up. We did ask people to put in A3- rather than A1-size drawings as much as possible, but they haven't actually done that. We also asked them to put real explanatory inserts on their drawings and models. Again they haven't done so; it's like trying to herd cats. The models are all going in the middle of the room except for one wall which has models which light up. The central feature of the gallery is a tribute to Denys Lasdun: a black-and-white photograph of him and ten photographs of his well-known schemes, such as the National Theatre, the Royal College of Physicians, and the flats in St James's. He was an important enough figure to merit that – a real great.' Among other exhibits of note, Manser cites the two paintings by Ben Johnson of minimalist schemes by John Pawson; a suave blue model for the South Bank by Future Systems; Ian Ritchie's etchings; and two large models by Rogers and Partners. The drawings, for the best of which a prize will be awarded, also claim attention, for example *Grove Terrace, Highgate Road* by Oliver Cox and a drawing by Roy Wright of Gaudí's Sagrada Familia in Barcelona.

Nicholas Grimshaw CBE, RA (Nicholas Grimshaw & Partners Limited)
The Eden Project (detail)
Photograph
19 × 19 cm

Prof. William Alsop RA (Alsop Architects)
Study for Broadcasting House
Model
H 21 cm

Lord Richard Rogers of Riverside RA (Richard Rogers Partnership)
Grand Union Building, Paddington Basin (detail)
Model
H 66 cm

Sir Michael Hopkins CBE, RA (Michael Hopkins & Partners)
Guy's and St Thomas' New Children's Hospital
Model
H 24 cm

Paul Koralek CBE, RA (Ahrends, Burton and Koralek Architects)
Carrickmines Croquet and Lawn Tennis Club, Dublin
Photograph
63 × 64 cm

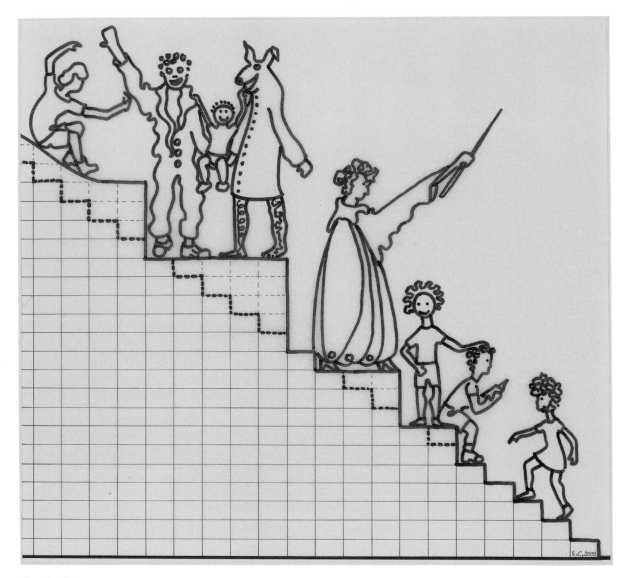

Edward Cullinan CBE, RA
Design for a Stair in a Children's Theatre
Ink on trace
28 × 31 cm

ROOF LIGHT

HIGH LEVEL SERVICES

HIGH LEVEL WALKWAY

KEY EXHIBIT
DETERMINES SIZE OF ENCLOSURE

BUILDING SITS LIGHTLY
ON CONCRETE PLINTH

ROOF LIGHT

CAFE ON INTERNAL TERRACE
WITH VIEWS OVER EXHIBITION

PLANT CONTAINED IN SIDE ZONES

LARGE BLANK WALL PERMITS DISPLAY,
OR FILM PROJECTION ETC.

GLAZED SCREEN ENVOLVES
WORKSHOP AS EXHIBITION

RAINWATER TAKEN AWAY
IN CONCRETE GULLEY

Michael Manser RA (The Michael Manser Practise)
Heritage Centre for Boats and Aeroplanes, Southampton Water (detail)
Computer generated image
30 × 40 cm

Ian Ritchie CBE, RA
Terrasson Cultural Greenhouse
Etching
8 × 29 cm

Eva Jiricna CBE, RA (Eva Jiricna Architects Limited)
Private Residence, London (detail)
Photograph
64 × 120 cm

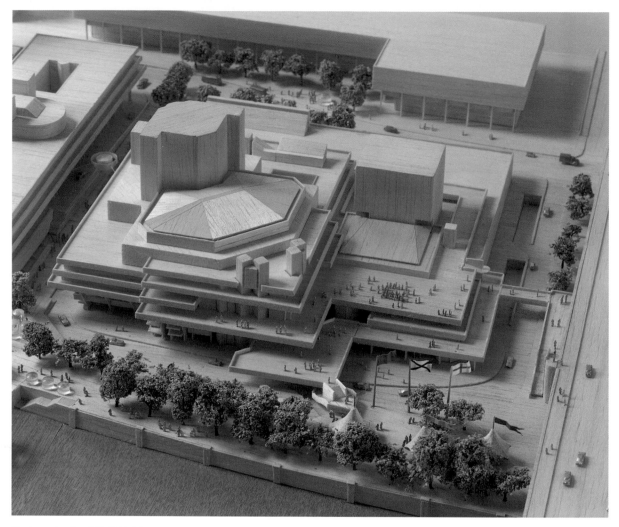

Sir Denys Lasdun CH, CBE, RA
National Theatre (detail)
Model
H 15 cm

Álvaro Siza
Museum Serralves Porto, Park Entrance
Photograph
67 × 100 cm

Richard MacCormac CBE, RA (MacCormac, Jamieson, Prichard)
West Cambridge Development, East Forum, University of Cambridge (detail)
Drawing
20 × 107 cm

Lord Norman Foster of Thames Bank OM, RA (Foster and Partners)
Paragon Research and Development Centre (detail)
Computer generated image
119 × 84 cm

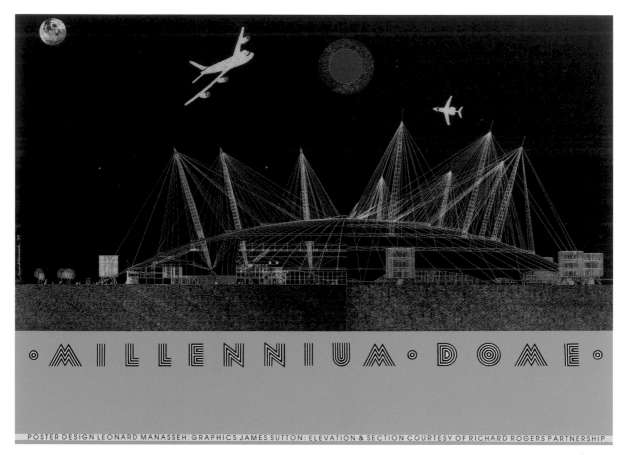

POSTER DESIGN LEONARD MANASSEH: GRAPHICS JAMES SUTTON: ELEVATION & SECTION COURTESY OF RICHARD ROGERS PARTNERSHIP

Leonard Manasseh OBE RA
Poster Commissioned for the Millennium Dome
Mixed media
59 × 84 cm

Prof. Trevor Dannatt RA (Dannatt, Johnson Architects
Royal Botanical Gardens, Kew, Feasibility Study
Drawing
90 × 75 cm

Lecture Room

This year the Lecture Room contains both prints and works on paper, which usually have a room each. Peter Freeth, its hanger, comments: 'The decision was made to build a screen right down the middle of the room. This proved to be enormous – rather like the Berlin Wall – so we had to cut it down and pull the two halves apart so that you could see across the room. The side screens were at first built too low so we added an extra two feet to get in a lot more small pictures which were obviously popular. [In all, there are twenty-two separate wall surfaces on which to hang work.] After that it was a question of squeezing in as many as we could – I was determined to get a lot of pictures up. I do believe very strongly in the democratic principle of the Summer Exhibition. A lot of people who don't normally get wall-space in central London can get a look-in.' By and large, the prints are on one side of the room and the works on paper on the other. 'I've tended also to hang a monochrome wall and a colour wall, and pictures are grouped in the most obvious ways – landscapes, figures, abstracts. I hope they're fairly coherent. There's a wonderful wall of Norman Adams and his wife Anna Butt; a wall of photograph-related works; and a group of nudes which I'm sure will be very popular, as ever. I think the general standard of the work is very high, and the technical standard of print-making is quite remarkable. There's an absence, I suppose, of really young artists; the work here is mostly pretty familiar. It's the perennial problem of the Academy: there's still a lot of quite unnecessary prejudice against the Summer Exhibition. We're not succeeding in breaking that down, which I'm very sad about. But who knows, maybe Peter Blake's initiatives will bring in a different audience and a different set of artists next year.'

Sarah Raphael
Small Objects Falling out of Love (detail)
Monoprint
15 × 15 cm

Bella Easton
Sevengods Sailing
Chine Collé Etching
18 × 25 cm

David Gluck
Blackfriars Bridge, London
Etching
60 × 79 cm

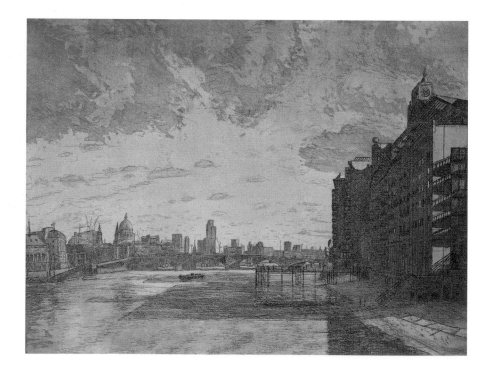

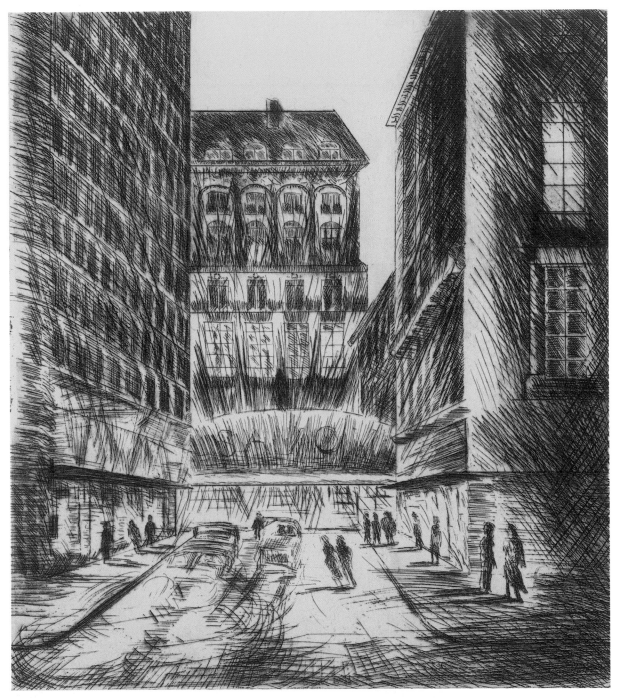

Toni Martina
The Savoy
Etching
35 × 31 cm

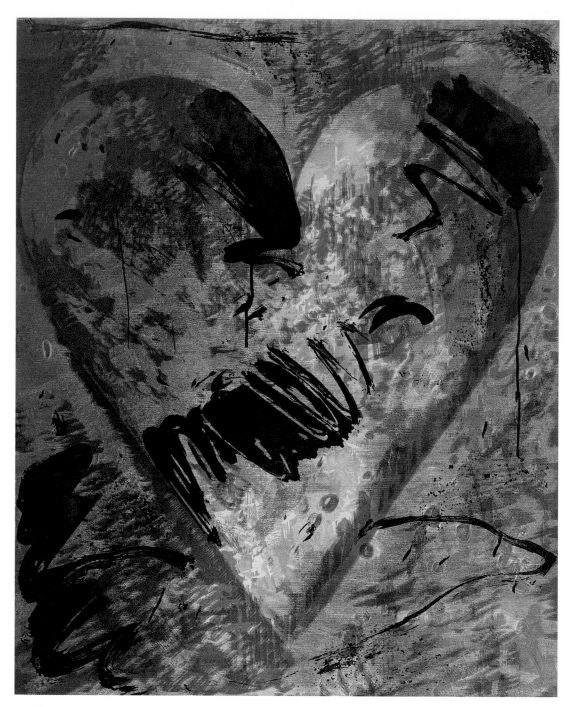

Jim Dine
Called by Sake
Woodcut
56 × 45 cm

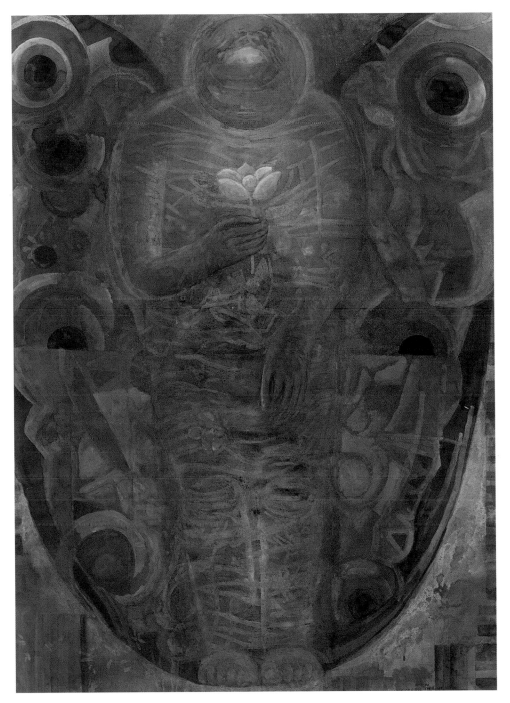

Prof. Norman Adams RA
Warrior Angel in memoriam Josef Herman
Watercolour
151 × 108 cm

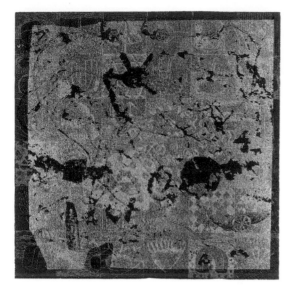

Sarah Raphael
Small Objects Falling out of Love
Monoprint
15 × 15 cm

Eileen Cooper
Fine Lines
Linocut
41 × 30 cm

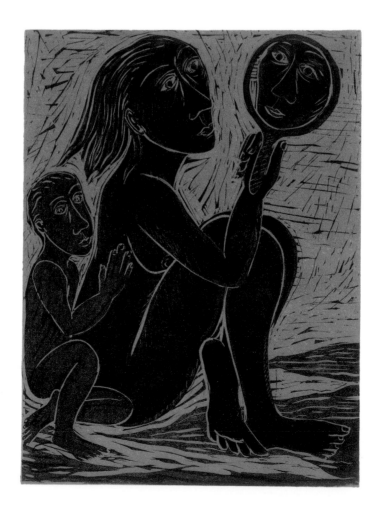

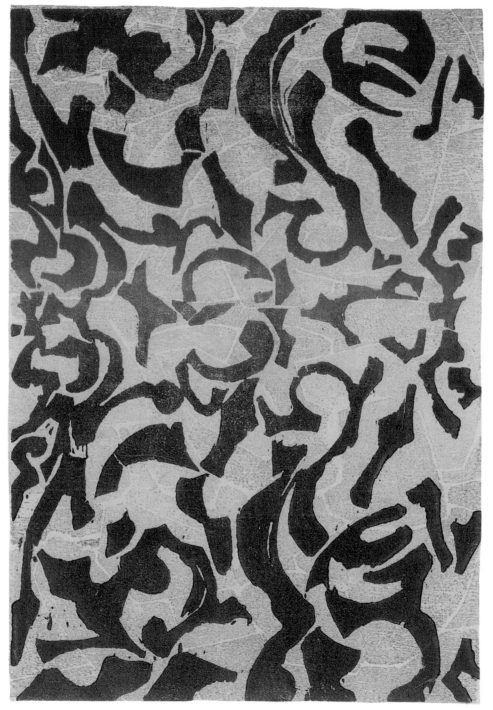

Thérèse Oulton
Untitled
Woodcut and monoprint
24 × 17 cm

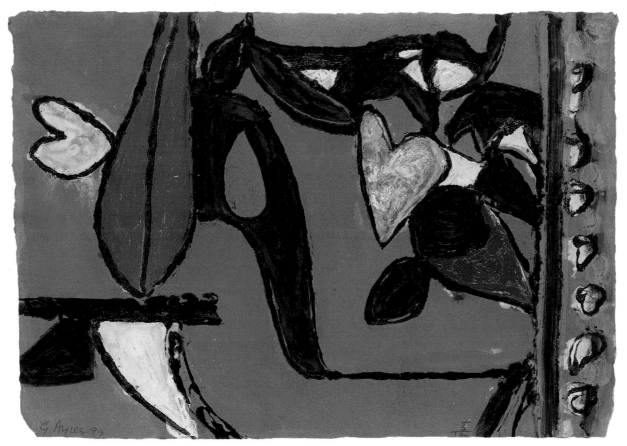

Gillian Ayres OBE, RA
Cinnabar
Carborundum etching
37 × 53 cm

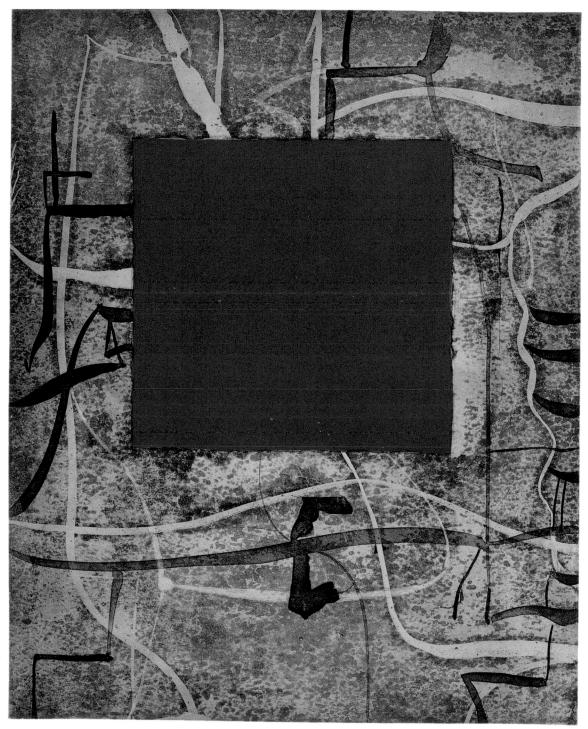

Maurice Cockrill RA
Heart from Anthology Suite
Aquatint and etching
50 × 40 cm

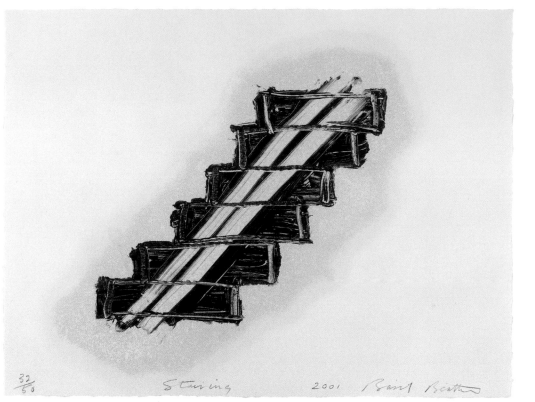

Basil Beattie
Stairing
Screenprint
40 × 44 cm

$\frac{32}{50}$ Stairing 2001 Basil Beattie

Charles Carey
Together again
Aquatint
13 × 15 cm

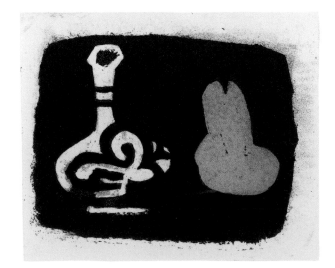

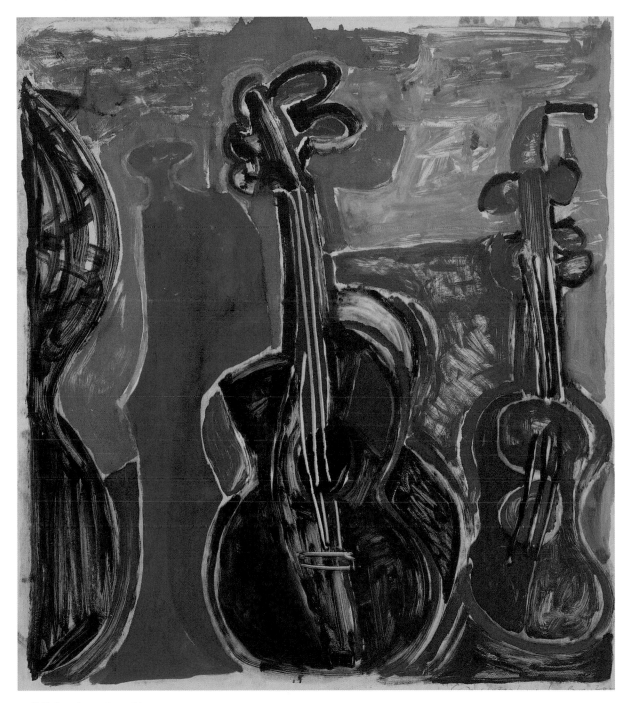

Prof. Christopher Le Brun RA
Guitar Music
Monoprint
109 × 97 cm

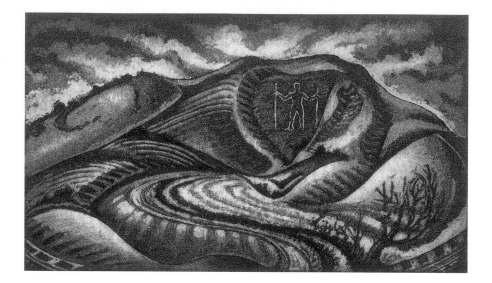

Jeremy Blighton
The Long Man
Etching and aquatint
9 × 16 cm

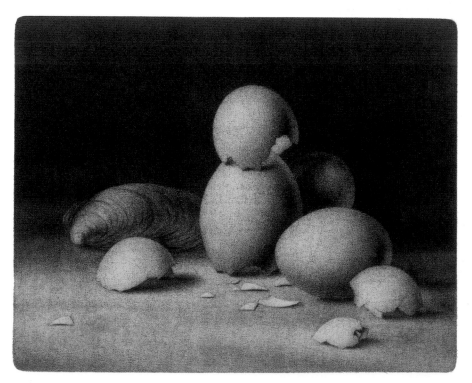

Konstantin Cumutin
Shells No. 6
Mezzotint
16 × 20 cm

Luigi Volpi
Still Life with Bottle
Etching
8 × 6 cm

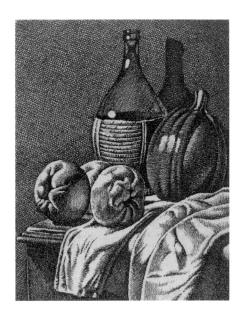

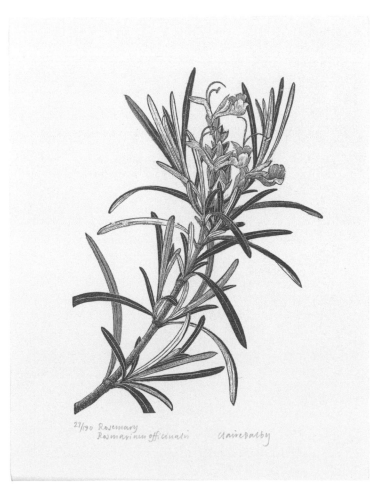

Claire Dalby
Rosemary
Woodengraving
14 × 10 cm

Julian Meredith
Eel
Woodcut
20 × 123 cm

James Butler RA
Model for 'Daedalus'
Bronze
H 54 cm

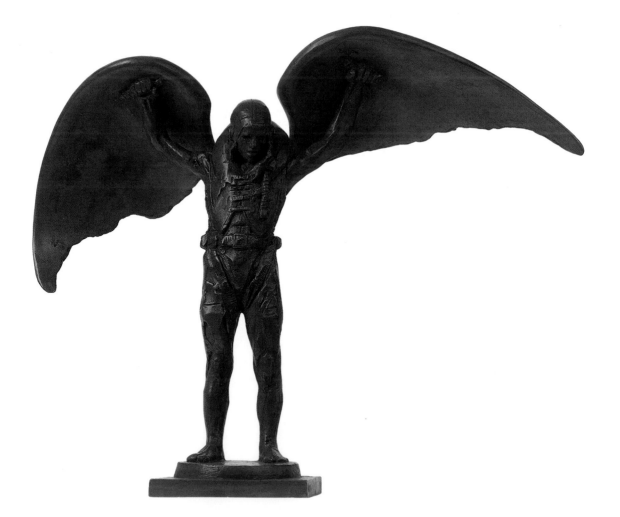

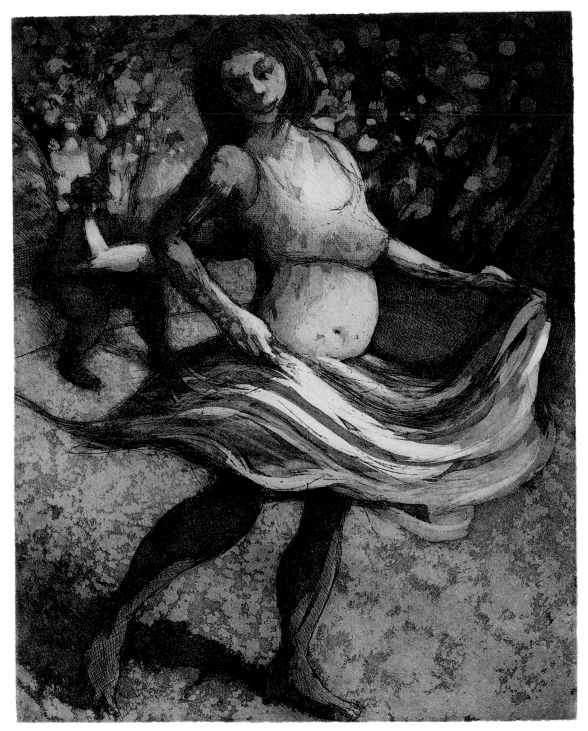

Bill Jacklin RA
Dancer, Washington Square
Etching
35 × 27 cm

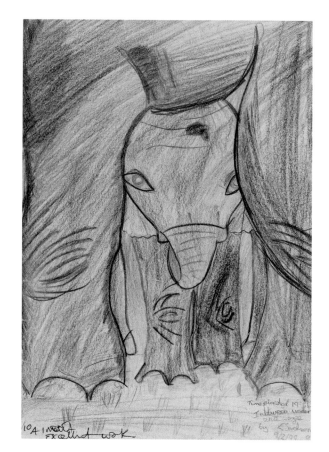

Elice Jackson
In Between, Under and Safe
Pencil
29 × 20 cm

Prof. Chris Orr RA
Saint Mick
Lithograph
50 × 65 cm

Prof. Bryan Kneale RA
Helmet
Copper
H 67 cm

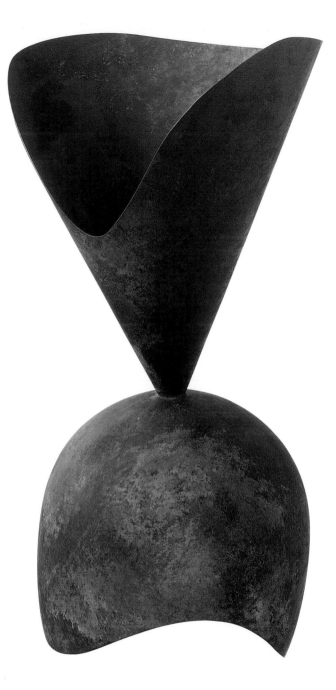

Peter Freeth RA
Road to Framura
Etching
9 × 12 cm

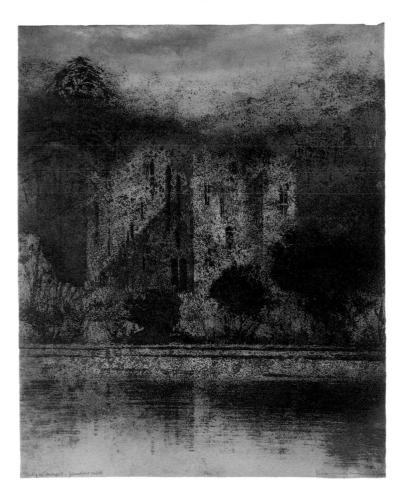

Prof. Norman Ackroyd RA
Study of Sunlight – Wardour Castle
Etching
61 × 54 cm

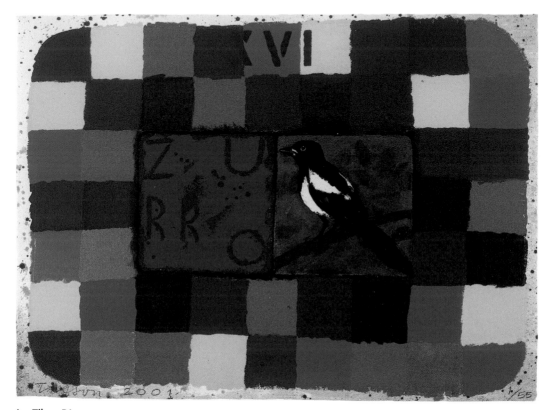

Joe Tilson RA
Conjunction Gazzaladra, Zurro
Screenprint on woodblock
56 × 77 cm

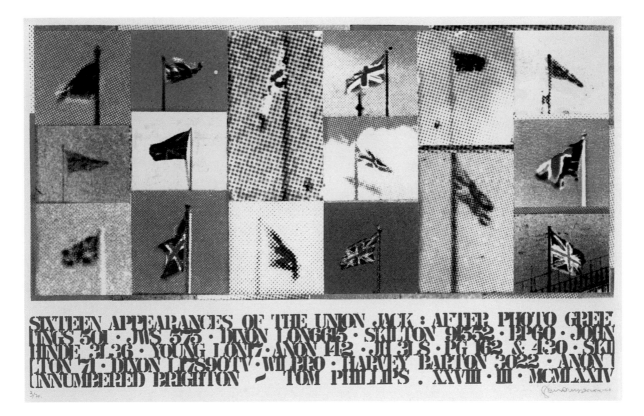

Tom Phillips RA
Sixteen Appearances of the Union Jack
Silkscreen
35 × 53 cm

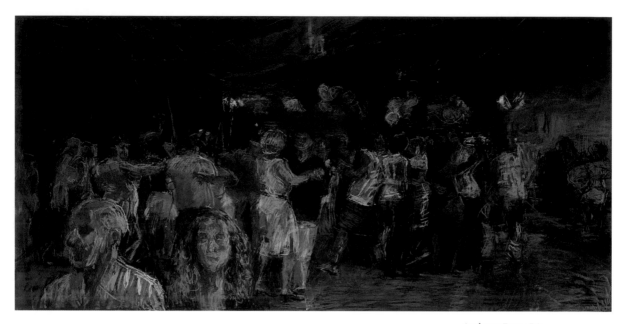

Anthony Eyton RA
Rio Dance at St Christophers
Pastel
90 × 180 cm

Paul Hogarth OBE, RA
Sphinx and Pyramid
Lithograph
47 × 65 cm

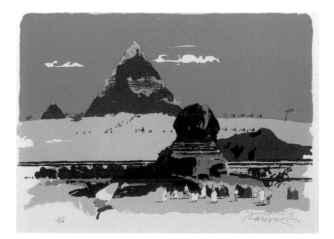

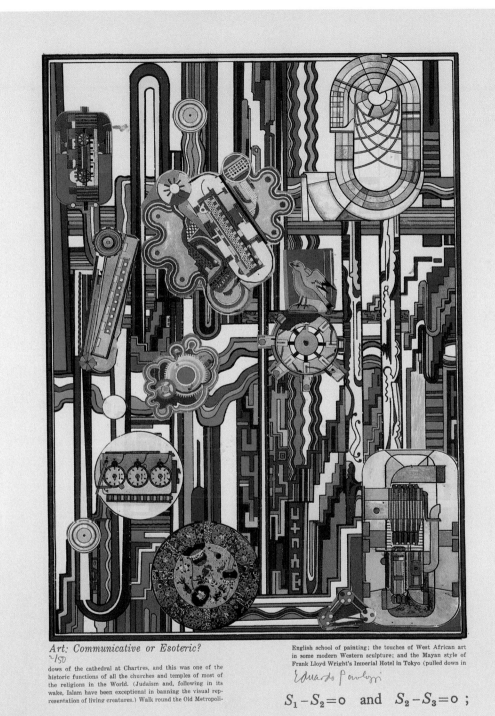

Prof. Sir Eduardo Paolozzi CBE, RA
Image 9 from the Turing Suite
Screenprint
76 × 55 cm

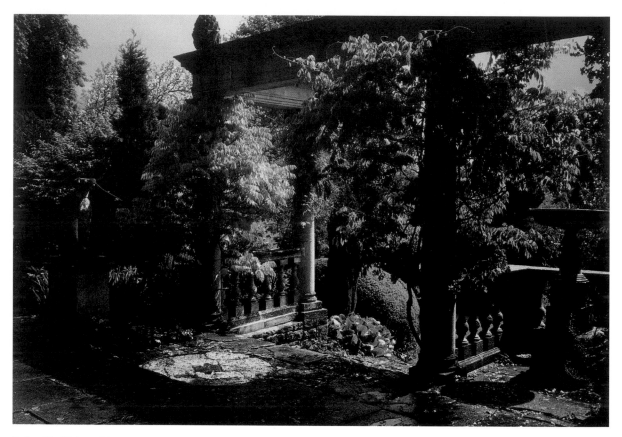

Dr Jennifer Dickson RA
Capitoline Fantasies (Iford Manor)
Giclée print
46 × 67 cm

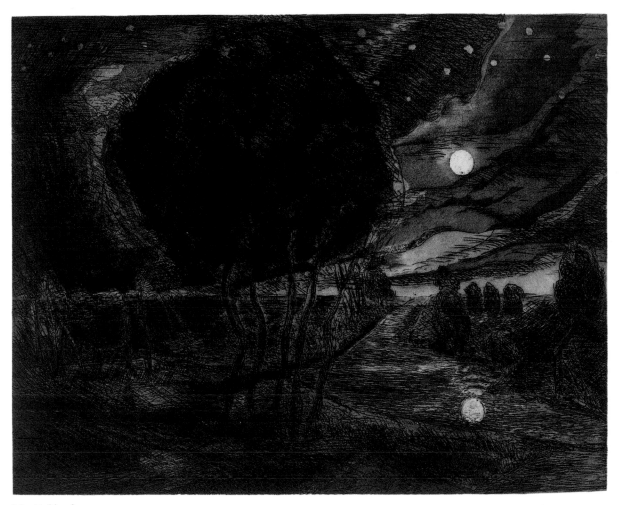

John Hubbard
After Rubens I
Etching
30 × 38 cm

Hilary Hanley
Secret Memories
Etching
8 × 7 cm

Paul Hawdon
Done with the Compass – Done with the Chart
Etching
49 × 99 cm

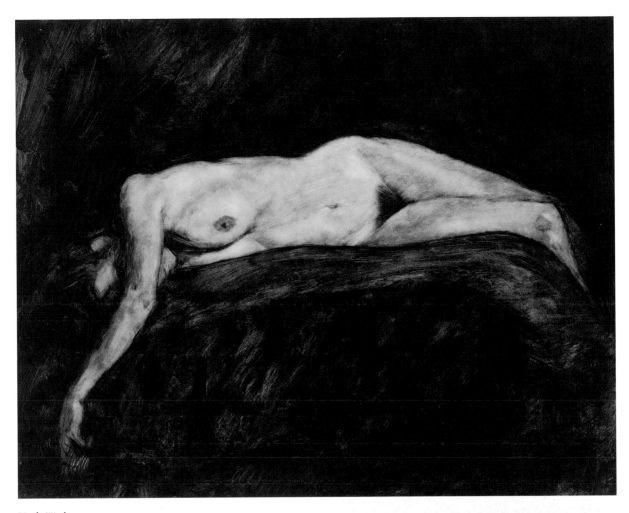

Neale Worley
Charlene
Monotype
36 × 44 cm

Dennis Jones
Head Study – Hazel
Drypoint
15 × 15 cm

Jean Cooke RA
... and she ended her days in a lime-washed Dove
Côte, Ovid Metamorphosis
Linocut
16 × 15 cm

David Hockney CH, RA
Dog Etching no. 9
Etching
27 × 46 cm

The last gallery in this year's Summer Exhibition features once more the work of the Academicians, and acts as a final punctuation point to what has been a distinctly innovative hang. Usually this gallery is hung with large paintings, but this year around the walls are groupings of small *intimiste* pictures: a clutch of odd-shaped vignettes by Jeffery Camp (hung, in Maurice Cockrill's words, 'in an eccentric constellation which I think complements the kind of work it is'); four fine still-lifes by Mary Fedden; and Anthony Green's wonderfully evocative paintings of tabletops. Cockrill decided to group the pictures by Diana Armfield and Bernard Dunstan, another husband-and-wife team, whose work also happens to be very close in style. Anthony Eyton's studio interior is hung on the line and looks very well there. A sub-theme of furniture – David Tindle's and Stephen Farthing's paintings filled with chairs, tables and drapery – has developed in an adjacent corner. As the principal feature of the gallery, an octagon has been constructed in its centre. Some eight feet in height, it echoes the room's shape and provides extra surfaces on which to hang, as well as supplying a fitting backdrop for Geoffrey Clarke's four wood and ceramic sculptures. Cockrill comments: 'It could have been a terrible intrusion, and looked a bit like a market stall, but it's not like that. It's a miniature, concentrated display of work. Apart from this lovely box by Peter Blake, *A Museum of the Colour White*, it's all sculptors' works on paper, by Ken Draper and Ann Christopher.' The gallery offers a healthy mix of sculpture and painting, with two brightly pigmented pieces by the President, Phillip King, holding the floor with considerable authority. One, entitled *Weeping Sibyls*, is a smaller version of part of the dramatic installation King made for his last exhibition at the Bernard Jacobson Gallery; the other is a chair made more for its metaphoric and aesthetic punch than for its functional quality – perhaps a fitting symbol of the Summer Exhibition as a whole.

Geoffrey Clarke RA
Solarplexus of the Mind
Mixed media
H 237 cm

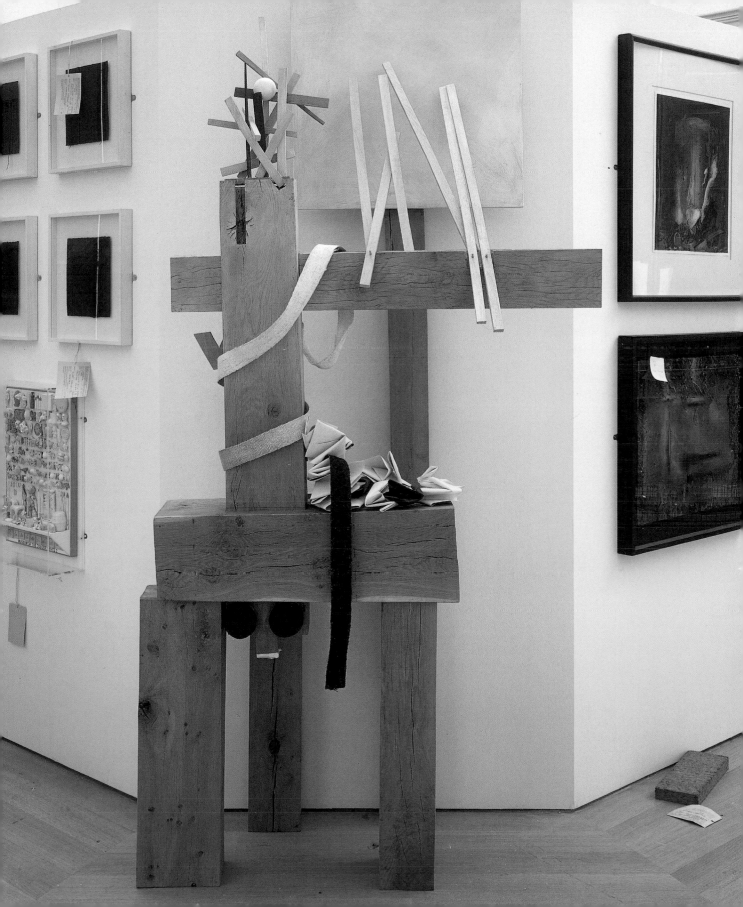

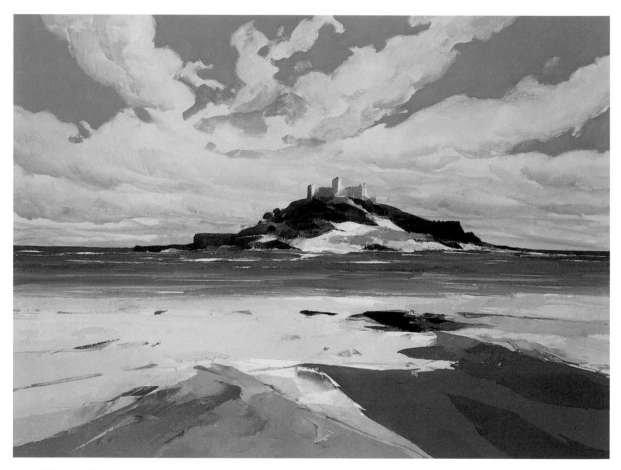

Donald Hamilton Fraser RA
St. Michael's Mount II
Oil
75 × 98 cm

Stephen Farthing RA
The Phillips Affair
Oil
40 × 50 cm

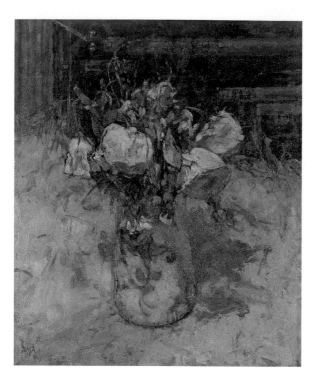

Diana Armfield RA
Flowers from Yvonne
Oil
29 × 24 cm

Bernard Dunstan RA
Interior – Mirror and Window
Oil
30 × 35 cm

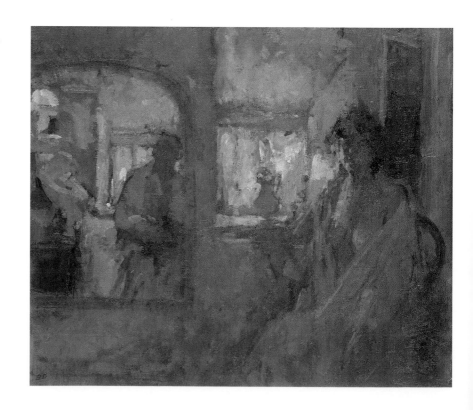

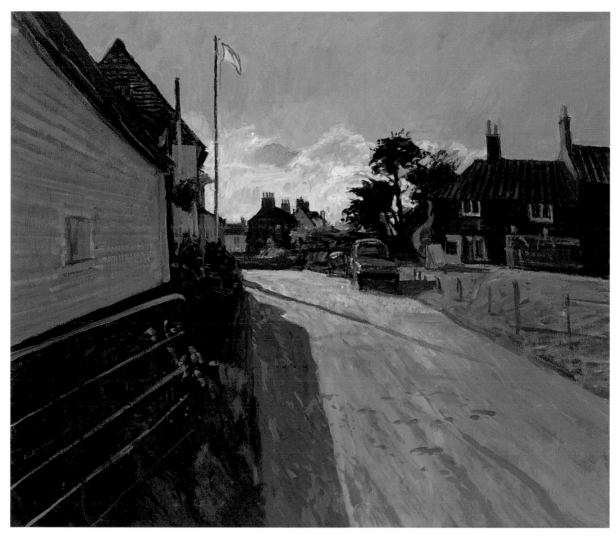

William Bowyer RA
The Bell Walberswick
Oil
71 × 81 cm

Ann Christopher RA
Silent Shadows – 5
Mixed media
28 × 24 cm

Kenneth Draper RA
Circles of Light
Pastel
50 × 45 cm

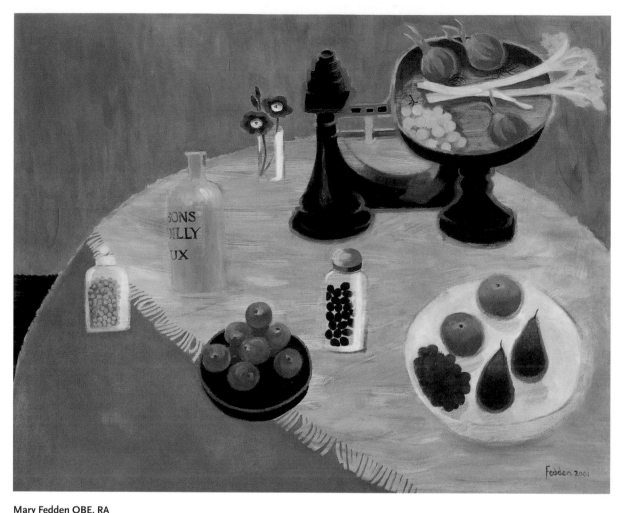

Mary Fedden OBE, RA
The Weighing Machine
Oil
101 × 127 cm

Jeffery Camp RA
Lime Cordial at Brighton
Oil
38 × 38 cm

Anthony Green RA
Still-lives, Flowers and Cups on a Lace Cloth
Oil
71 × 72 cm

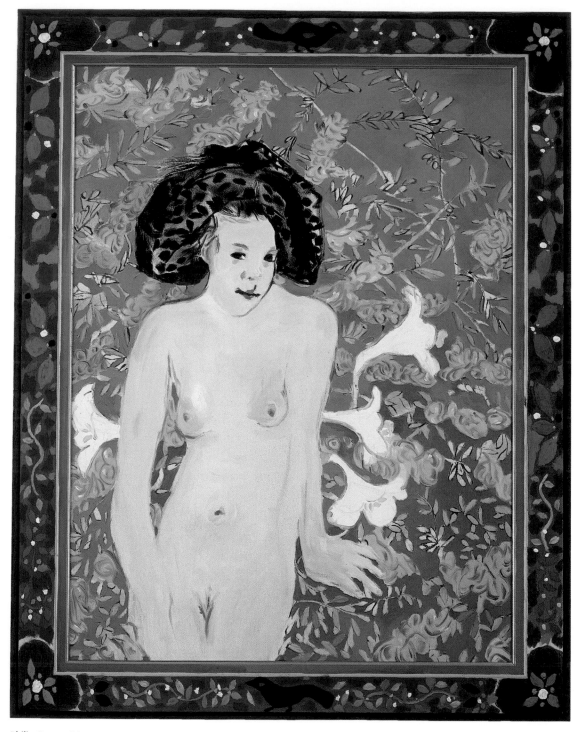

Philip Sutton RA
There is a Spirit in the Woods
Oil
120 × 93 cm

Robert Clatworthy RA
Standing Figure
Acrylic
54 × 36 cm

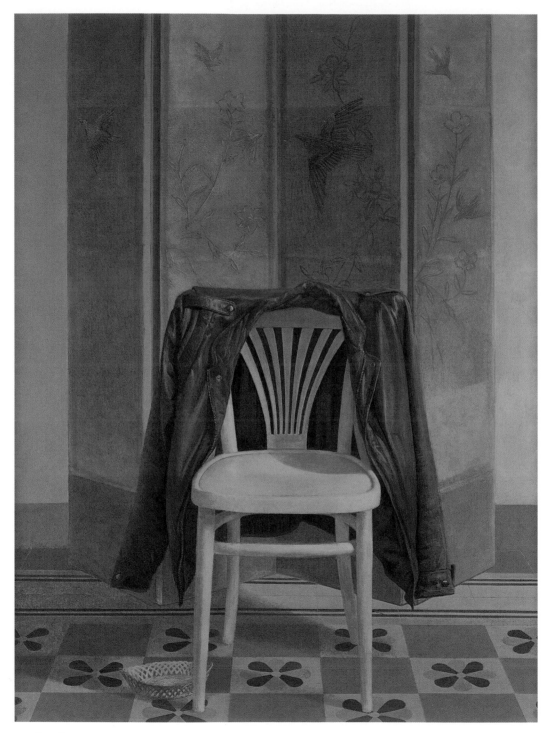

David Tindle RA
Jacket and Screen
Tempera
79 × 59 cm

Flavia Irwin RA
Suspended Animation
Watercolour and coloured pencil
74 × 59 cm

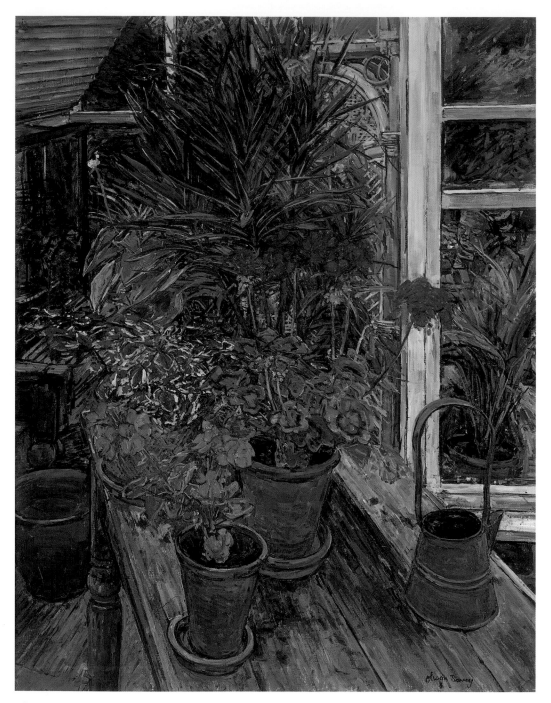

Olwyn Bowey RA
The House Plants
Oil
90 × 70 cm

Carey Clarke
*Still Life: Roses,
Peaches and Plums*
Oil
70 × 105 cm

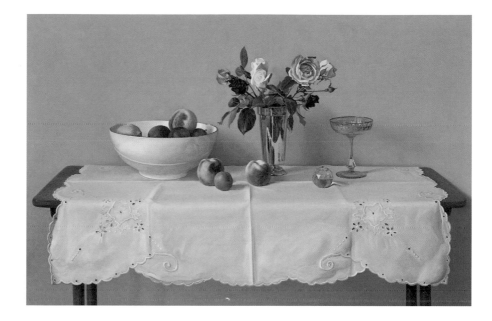

Ben Levene RA
Shubunkin
Oil and silverleaf
71 × 60 cm

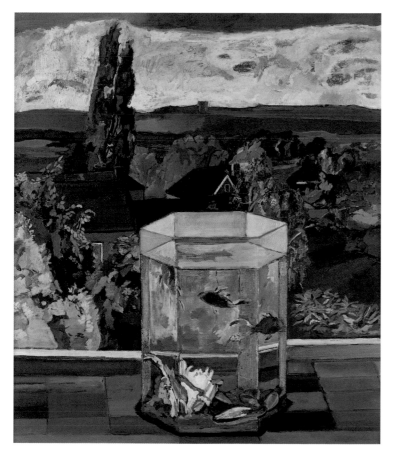

John Wragg RA
Harlequin
Jesmonite
H 125 cm

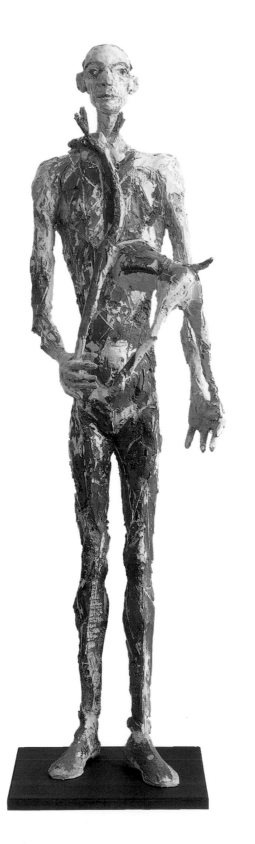

Prof. Phillip King CBE, PRA
Weeping Sibyls
Mixed media
H 60 cm

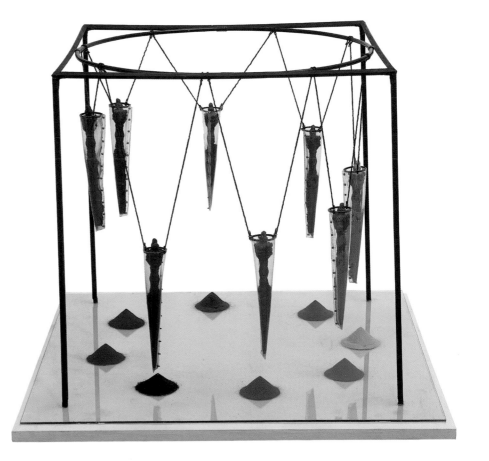

Index

Royal Academy of Arts in London, 2001